IMAGES
of America

HAMPTON BAYS

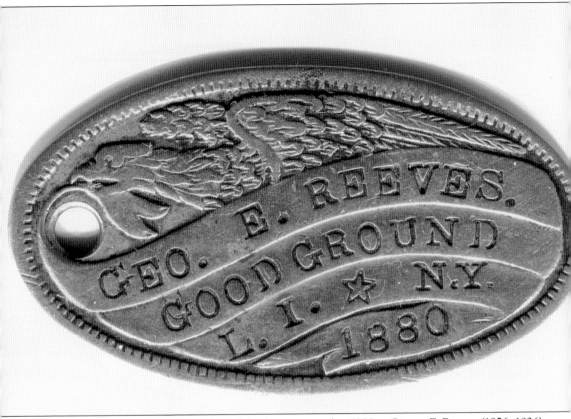

IDENTIFICATION TAG. This is a silvered dog license issued in 1880 to George E. Reeves (1856–1926) of Hampton Bays (formerly Good Ground). (Author.)

ON THE COVER: Wendell Squires (left) and Noble Chapman are posed for a great day of hunting around 1908. (Hampton Bays Historical and Preservation Society.)

IMAGES
of America

HAMPTON BAYS

Geoffrey K. Fleming

ARCADIA
PUBLISHING

Copyright © 2014 by Geoffrey K. Fleming
ISBN 978-0-7385-9281-7

Published by Arcadia Publishing
Charleston, South Carolina

Printed in the United States of America

Library of Congress Control Number: 2012933145

For all general information, please contact Arcadia Publishing:
Telephone 843-853-2070
Fax 843-853-0044
E-mail sales@arcadiapublishing.com
For customer service and orders:
Toll-Free 1-888-313-2665

Visit us on the Internet at www.arcadiapublishing.com

CONTENTS

ACKNOWLEDGMENTS

This book would not have been possible without the careful acquisition and cataloguing performed by the Hampton Bays Historical and Preservation Society staff, board, and volunteers. For such a new society, it has come a long way during its short existence. While the great majority of the images and research came from the collection of the Hampton Bays Historical and Preservation Society, some were also made available from other sources. The author wishes to thank the reference staff of the Hampton Bays Public Library; Brenda Berntson, who scanned several of the images for this book; Amy Folk for her research assistance; Walter R. Jackson for his help in researching and proofing the content and images used; Merle Mason for help organizing photographs; Robert Mueller, curator of the Salmagundi Club in New York City, for some of the images of American artists; and Elizabeth White for her help in providing valuable information on Hampton Bays. George P. Tetzel, Hope Sandrow, and Ulf Skogsbergh are also due thanks for their help with this book. Barbara Moeller is due a special thanks for her two important studies of Hampton Bays, as are the late Helen Wettereau and Emma L. Bellows for their work in preserving many of the interesting tales and stories connected with Hampton Bays. Images and information are courtesy of the following public and private collections: Albert Chittenden, scan of original photograph from his photograph album "Shinnecock Hills and Southampton 1901," courtesy of a private collection (UHS); George Tetzel (GT); Hampton Bays Historical and Preservation Society (HBS); *Koumbaroi: Four Artists of the Shinnecock Hills*, photograph courtesy Fine Arts Gallery, Long Island University, Southampton College, Southampton, New York, reproduced with permission of Roy Nicholson (KOU); Library of Congress (LOC); the William Merritt Chase Archives, Parrish Art Museum, Southampton, New York, gift of Jackson Chase Storm (PAR); Palestine Public Library, Palestine, Texas (PPL); Walter R. Jackson (WRJ); Salmagundi Club (SC); Town of Southampton, Office of the Town Clerk, Historic Division (ST); Southold Historical Society (SHS); and the author (Author).

INTRODUCTION

When I first came to live in Hampton Bays more than a decade ago, I chose it not because of its location, or natural beauty, or proximity to beautiful beaches. I chose it because it was inexpensive compared to many of the other hamlets and villages on Long Island's South Fork. Perhaps that is the charm of this village. Though it has been forced, time and again, to be more like its wealthy neighbors, it keeps reverting back to a place where regular folks can get by while still enjoying some of the amenities associated with the Hamptons.

But Hampton Bays, once known as Good Ground, was not always like this. When it was founded, Good Ground was little more than one small hamlet surrounded by several other small hamlets. These included Canoe Place, East Tiana, Newtown, Ponquogue, Rampasture, Red Creek, Southport, Springville, Squiretown, and West Tiana. Only over time would they become the Hampton Bays we know today. In 1659, Hampton Bays started to take shape with the completion of John Ogden's purchase of the land west of Canoe Place all the way to present-day Westhampton. A number of other individuals, including John Scott, owned this large piece of land before the Town of Southampton acquired it. In 1738–1739, the "Quogue Purchase–Canoe Place Division" was divided into lots by the proprietors of Southampton. Farming, fishing, offshore whaling, and shellfishing became important to the local populace.

The establishment of the post road on the South Fork in 1765 ensured that the communities located along it would grow and prosper. In the 1770s, stagecoaches began making their way at regular intervals from Sag Harbor to Brooklyn, though one had to travel "through darkened woods" to complete his journey. During the early 19th century, roadways were expanded, and in December 1869, the Long Island Rail Road arrived in Hampton Bays. With its arrival, the ability of city people to easily reach the South Fork led to it becoming a popular social spot during the summers. In addition, artists came in groups to study, paint, and draw the many picturesque places. The Tile Club, along with young artists like Irving R. Wiles and Burr Nichols, began to take in and appreciate the natural beauty of the South Fork.

This appreciation continued under the famous William Merritt Chase, who founded his school of art in Southampton in 1892, which continued each summer through 1902. Art students would traverse the Shinnecock Hills, located just to the east of Hampton Bays, and wander the inlets and farms of the South Fork, painting the landscapes and seascapes found there. Chase, like the painter Charles Henry Miller, was very influential in bringing artists out onto Long Island in large numbers. This is a tradition that grew during the 20th century under the influence of newly arrived artists such as David Burliuk, Nicolai Cikovksy, George Constant, Harry Gottlieb, Theo Hios, Moses and Raphael Soyer, and Nat Werner. It is a tradition that still continues to this day.

The railroads promised a better life for many in Good Ground, and they quickly began opening their homes to summer visitors. First, they would operate boardinghouses, but as the summer trade grew stronger and stronger, larger and more modern hotels began popping up. Among these were the Clifton Hotel and the Bellows House, which offered visitors some of the first indoor plumbing;

Bellows House's food was also said to be "out of this world." For a brief moment in 1892, the name Good Ground was changed to Bay Head by the railroad, but before the year was up, it was returned to its former name due to community pressure. By the very late 19th century, many notable men associated with Tammany Hall, the powerful Democratic political machine located in New York City, began to build homes and summer at their large estates in Good Ground. They were among the first to think that this somewhat sleepy little town could be much more like her neighbors farther east. This change would, however, require another alteration in name.

The change of the name from Good Ground to Hampton Bays can be singularly attributed to the perseverance of Judge Wauhope Lynn (1856–1920), whose estate, Lynncliff, once stood along the bay and who wanted to bring his summer home into the society belt. In October 1900, the *Suffolk County News* reported, "The name of Good Ground will be changed to Bayhampton as soon as the post office authorities can make the necessary arrangements as 90 percent of the population voted to make the change." How and why the vote occurred is unclear. The *New York Herald* noted the following shortly after the event: "Why 90 percent of the inhabitants should vote for this . . . is puzzling." By November of that year, following Lynn's election to the state assembly, local residents were up in arms, rejecting Lynn's attempts to rename the village, which residents thought could be either the previously proposed Bayhampton or even the rumored Lynnhampton. The *New York Herald* reported that local residents thought that "Good Ground was satisfactory to their forefathers, and therefore, they say, it is good enough for them."

The name Bayhampton did not immediately catch on, with older residents still opposing it. However, as time passed, and older residents died off, Lynn was able to press his cause further. In October 1920, exactly 20 years since his first proposal, a petition signed by 250 residents of Good Ground was laid before the Southampton Town Board requesting the name change to Bayhampton, with only 25 signatures in opposition. Therefore, following a public meeting in Good Ground on October 27 and without any significant opposition, in November of that year, the Southampton Town Board officially approved the name change. Lynn, who had died the previous August, never lived to see the dramatic shift in public opinion. The US Post Office Department, which also had to approve the change, apparently did not agree with the new name and may have been the source to recommend that the village use Hampton Bays instead of Bayhampton. Though it has been reported that the change may have been made because it was too similar to Bridgehampton, it is more likely it was due to the fact that there was already a Bayhampton Park, located on Long Island near Freeport, that had been established by 1907.

Some sources quote 1920 or 1924 as the official year the name was changed to Hampton Bays; however, it was actually 1922 when Good Ground ceased to exist. The official time and date was 3:00 p.m. on Tuesday, February 14, 1922—St. Valentine's Day. This proved too much for the local post office, which continued to use the old Good Ground postmark for some time afterward, resulting in, among others things, returned mail stating there was "no such place." Local establishments advertising in city papers in 1923 noted their businesses were located at "Hampton Bays, formerly Good Ground." When Gov. Alfred E. Smith (1873–1944) visited the hamlet in 1926 for the dedication of a statue in memory of his longtime political friend Charles F. Murphy, Smith "seemed to immediately win his audience by refusing to refer to the community as anything other than Good Ground." For many, there was still a continuing hope and longing for the old name. As late as 1929, one local writer noted, "We hope that Good Ground and Horseheads and Painted Post N.Y., will ever retain the flavor of their names." But it was not to be; by the time this was written, the name Hampton Bays had begun to catch on and would come to redefine the community.

Soon, a community newspaper bearing the name the *Hampton Bays News* sprang up, reporting every incident or modest event that took place in the village. The new name absorbed many of the older ones associated with nearby hamlets, and today, few people in town could tell you where their borders began or ended. As the automobile took over America, it spelled doom for the larger hotels and boardinghouses in town. People could travel greater distances more easily, and so there was no longer any reason to summer so close to home. One by one, the buildings

vanished, either torn down or more commonly destroyed by fire. People who did continue to visit built small summer cottages developed around the village or summered at one of the few remaining large hotels, such as the Canoe Place Inn.

Locals and summer residents might have mingled, but it was the locals who never quite came to trust the summer residents—especially after the long-drawn-out fight that changed the community's name. Many natives called the summer people "pin-hookers," a reference to their supposed incompetence when it came to fishing. But locals knew a good thing when they spotted it and established businesses that supported nearly every aspect of summer life, whether it was the need for groceries, rented pianos, gasoline stations, repair shops, or laundries.

The later part of the 20th century saw Hampton Bays become comfortable with its new name and place on the South Fork. With the opening of the Ponquogue Bridge in the 1930s, a superb beach, once mostly owned by Judge Lynn, was available to the greater public. This made the community even more attractive to people looking for second homes, and many were built in the new developments that sprang up as the older summer estates were demolished and sold for that purpose. Even with all these changes, though, the residents of Hampton Bays never became as full of themselves as some of their neighbors. The community remained, by choice, a place where the regular guy could have a taste of the sweet life without bankrupting himself.

And that is perhaps the village's most charming aspect. It is not like Quogue, or Westhampton, or Southampton, Bridgehampton, or even East Hampton. It is Hampton Bays, an outpost of colonial settlement that has become, much to the shock of its neighbors, one of the favorite Hamptons beach spots—without all the expense, contrivances, or brouhaha. It seems like the locals have finally had the last laugh after all.

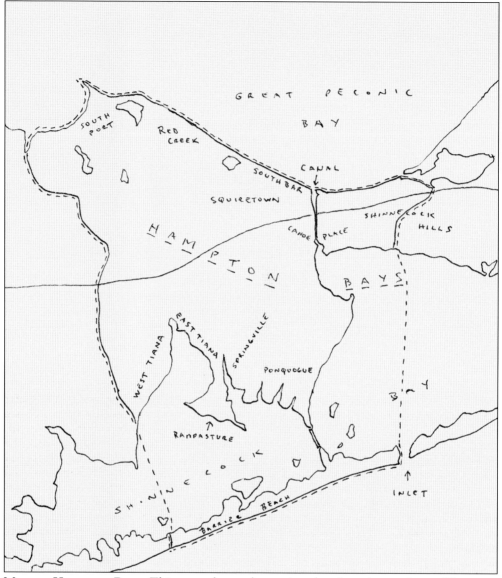

MAP OF HAMPTON BAYS. This map shows the various hamlets that make up Hampton Bays. (Author.)

One

COMMUNITY

Hampton Bays, unlike many of its neighbors, never had an early meetinghouse that was later transformed into a Presbyterian church. Among its earliest religious institutions was the Canoe Place Chapel, which was founded in the 1790s by a New York missionary society to help with the conversion of the Shinnecock Indians to Christianity. The Methodists would arrive in the mid-1830s, followed by the Catholics in the late 19th century, then by the Episcopalians soon after, and today, the Lutherans. The earliest school that still stands today and was associated with the village's history is the Red Creek Schoolhouse, which now is located on the grounds of the Southampton Historical Museum. A number of later buildings were constructed, both in and around the village, but almost none of those survive today. The one that does, the Hampton Bays Public School on Ponquogue Avenue, is a reminder of the days when classicism in school architecture was a given. Other community organizations, such as the Hampton Bays Band, also left their marks. Regardless of the age of a building or the people who made their groups successful, each has left an indelible mark on the village.

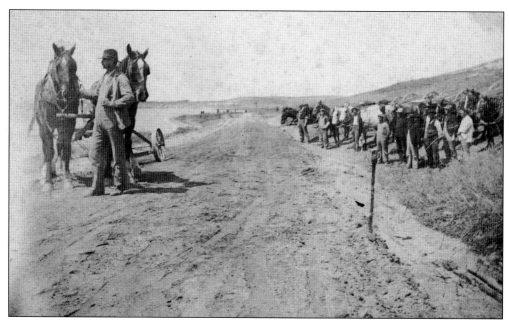

ROAD CONSTRUCTION, 1890s. Good roads were essential to commerce, and at the dawn of the 20th century, there were few good, paved roads in the area. In this image, a road crew works on the highway that to this day skirts the bay along the Shinnecock Hills. It was not until 1915 that Montauk Highway was paved with concrete through Hampton Bays. (HBS.)

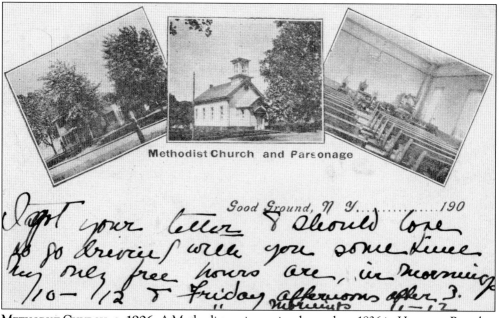

METHODIST CHURCH, C. 1906. A Methodist society existed as early as 1836 in Hampton Bays, but it was not until 1840 that the first church was constructed. On May 15, 1907, a fire destroyed the second Methodist church building, constructed in 1863. The blaze also consumed the neighboring Woodmen's Hall. The fire began in R.T. Tuthill's store, which was located in a building owned by E.H. King. The original parsonage stood next door and was later relocated to Springville Road. (HBS.)

12

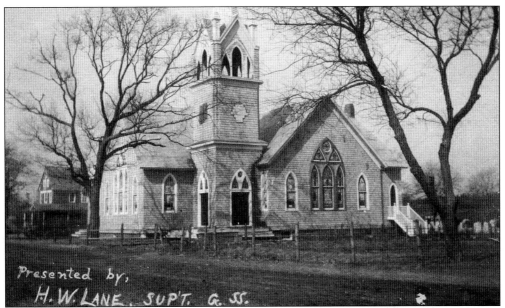

Presented by,
H. W. LANE, SUP'T. G. SS.

METHODIST CHURCH AND PARSONAGE, C. 1908. Following the fire, a new Methodist church was needed. It was designed by Arthur W. Bird, and was dedicated on March 15, 1908. When local builder William W. Jackson completed it, the new church was free of debt—its members having raised all the necessary funds for its completion. A new parsonage was built across the street and was later sold and replaced by the Eastern Federal Savings & Loan Building, the present-day Matsulin, a Pan-Asian restaurant. (HBS.)

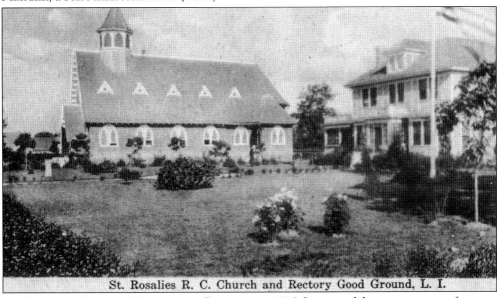

St. Rosalies R. C. Church and Rectory Good Ground, L. I.

ST. ROSALIE'S CATHOLIC CHURCH AND RECTORY, C. 1915. In most of the communities of eastern Long Island, those of the Catholic faith found it difficult to acquire land for the construction of a church. Their activities often met stiff resistance from Protestant families that had dominated theses areas since the 17th century. Bishop McDonnell of Brooklyn oversaw the construction of many of the parishes in Suffolk County and sent Rev. William C. Reilly to oversee expansion into Hampton Bays. (GT.)

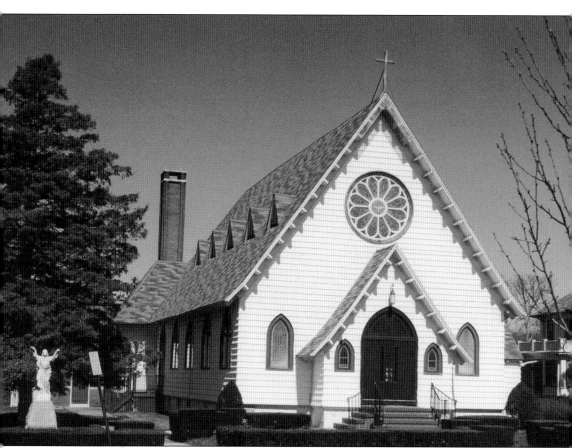

St. Rosalie's Catholic Church, c. 2005. Summer resident Judge Morgan J. O'Brien funded the acquisition of the land that would become St. Rosalie's, and in 1901, construction of the new church began—though its first proposed name was Church of the Sacred Heart. It is interesting to note that the many speakers who attended the ground-breaking ceremony spoke about the fact that they had been raised and taught that "Catholics were the enemies of civil and religious liberty," but they had since had their minds changed by the "magnificent work they are doing." Fred E. Penny was the builder, and in March 1902, a benefit musicale was held at the Savoy Hotel in New York City in support of the effort. The church was formally dedicated August 17, 1902, and was expanded with the addition of an auditorium designed by Norman Behrens in 1958. A new church building, completed in 1996, rendered the old building obsolete, and it was converted into the present Knights of Columbus Hall. (HBS.)

CANOE PLACE CHAPEL, C. 2005. The chapel building, which may date to before 1812, is most associated with its famous pastor, the Rev. Paul Cuffee (1757–1817), a Shinnecock Indian, who preached to the local Native American tribes "with fidelity and success." Though, in 1943, the building received electric lights, it has not been heavily modernized, and has now been preserved by the Town of Southampton. (HBS.)

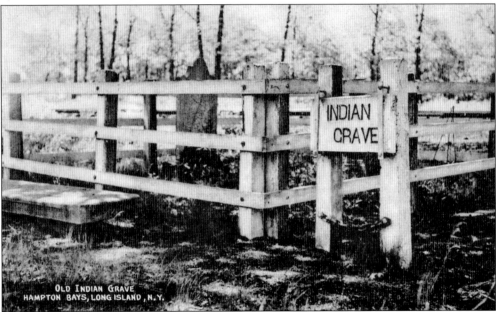

THE GRAVE OF REVEREND CUFFEE, 1930s. The New York Missionary Society placed Paul Cuffee in Southampton to convert and minister to the local Native American population. His grave was part of a larger Native American burial ground, which runs alongside the present-day Long Island Railroad tracks. He was noted as being "humble, pious, and indefatigable in testifying the gospel of the grace of God." (HBS.)

ST. MARY'S EPISCOPAL CHURCH, C. 1950. The first Episcopal church in Hampton Bays held its services in the home of Earl B. Squires, opposite the site of the present church, in 1912, and then in the old Silver Link Sewing Society Building. Virginia Taylor Hardy of Hardy Hall erected the present church between 1917 and 1920, in memory of her mother. Mrs. Hardy later donated the rectory (1926) and parish house (1931). The stained-glass windows in the baptistery are by the noted artist Otto W. Heinigke (1879–1968). (HBS.)

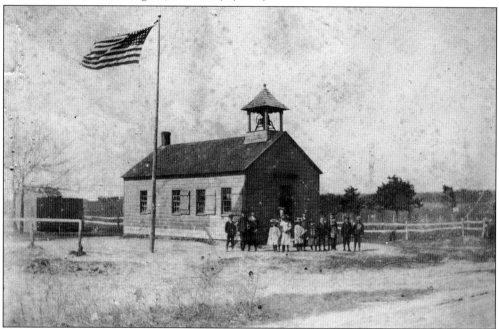

THE OLD DISTRICT NO. 5 SCHOOLHOUSE, C. 1890. This is the one-room schoolhouse that predated most others in the community and was located in the south side of Montauk Highway. These small schoolhouses would eventually be consolidated into larger union free schools. As early as October 1875, a union school joining the Ponquogue and Springville School Districts was publically discussed. The American flag flown at left was used between 1890 and 1891 when several new states joined the union. (HBS.)

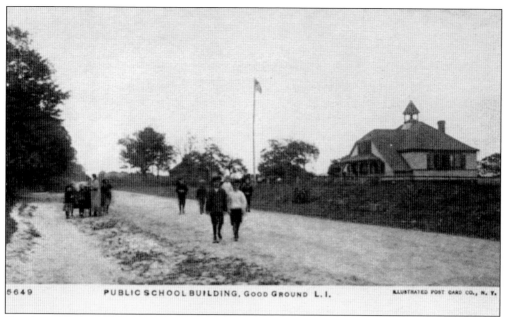

THE SECOND GOOD GROUND SCHOOL, C. 1900. The second school was built around 1892 following a fire that severely damaged the old one-room schoolhouse in 1891. It represented School District No. 5 and was an interesting shingle-covered structure, built with a sweeping roofline close to the ground. It was used until 1908, when the union free school was completed on the west side of Ponquogue Avenue. (HBS.)

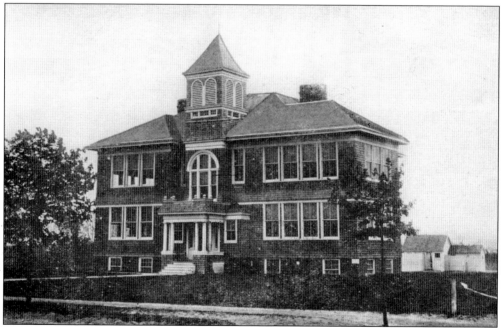

THE NEW GOOD GROUND SCHOOL, C. 1910. The union free school was completed in April 1908 along Ponquogue Avenue, replacing the smaller Good Ground and Springville Schools. To honor the two closing buildings, the bell from the old Good Ground School and the flagpole from the old Springville School were brought to the site and installed. (GT.)

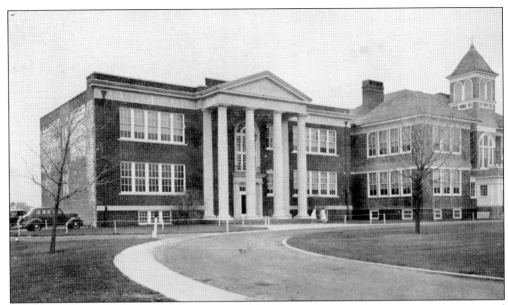

HAMPTON BAYS UNION SCHOOL, C. 1935. In 1923, a brick addition with a portico was constructed to the south side of the 1908 building. It housed the first regulation gymnasium and auditorium constructed in Hampton Bays. The 1908 union free school building was demolished on February 18, 1968, and replaced with a new structure. (HBS.)

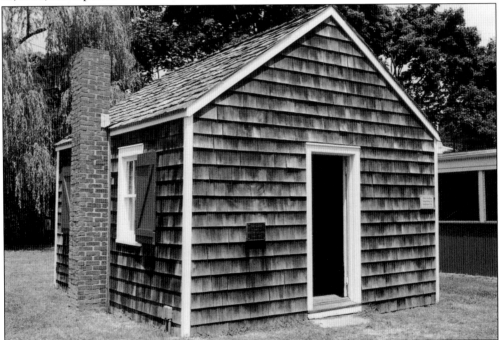

RED CREEK SCHOOLHOUSE, C. 2005. The Red Creek Schoolhouse was one of the small district schools located north of Hampton Bays. Built prior to 1874, the building was used as a school until 1890, when Red Creek was absorbed into the neighboring Flanders School District. The building was sold to W.W. Hubbard in 1915, and later, he sold it to the Southampton Historical Museum in 1952; the museum still owns the schoolhouse today. (HBS.)

THE HAMPTON BAYS BASKETBALL TEAM, c. 1924–1925. Pictured are, from left to right, (sitting) William Bangston, James Adams, and Mrs. Weller (teacher); (standing) Morris Martin, Henry Frances, and Chester Jacobs. (HBS.)

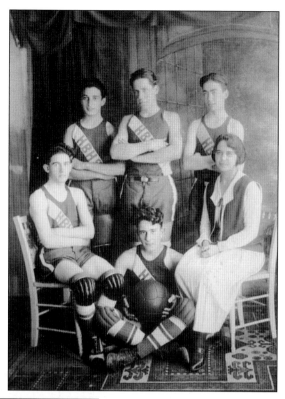

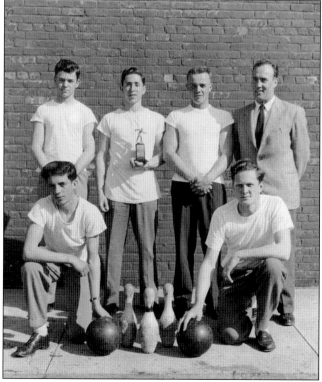

HAMPTON BAYS BOWLING TEAM, EARLY 1950s. The Hampton Bays School did not have bowling lanes, so the school team practiced and held meets at the American Legion Building. There were two lanes, and until 1959, the pins had to be set by hand. Pictured are, from left to right, (kneeling) Al Martin and Phil King; (standing) Ralph Lydecker, Jack Greenberg, Bill Kozofsky, and Coach Lopez. (HBS.)

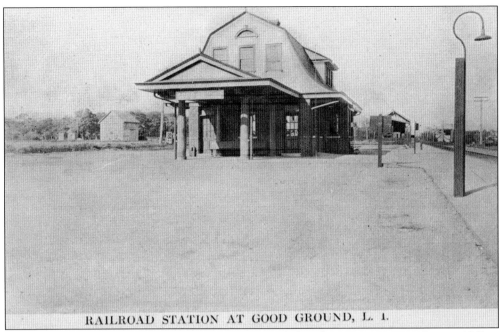

RAILROAD STATION AT GOOD GROUND, L. I.

GOOD GROUND TRAIN STATION, C. 1920. Though the railroad came to Hampton Bays in 1869, it was not opened for business until the winter of 1871. A fire destroyed the building in 1873, and a new station was constructed to replace it in 1874. The Tammany crowd, including summer resident Charles F. Murphy, helped to have a newer-style station built in 1916, located off Ponquogue Avenue. The station was closed in the 1970s, suffered a fire, and was finally torn down. (GT.)

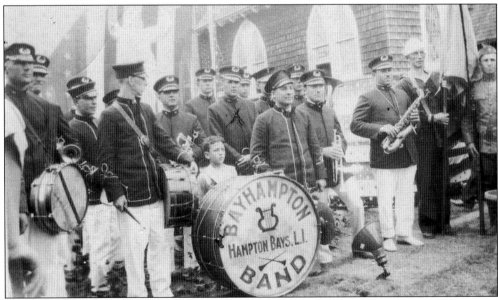

HAMPTON BAYS BAND, 1920s. A staple of community life, the Hampton Bays Band was organized in the 1920s by Fred Phillips and performed at all manner of events and affairs. Note that the drum has the Bayhampton name on it—the name originally chosen to replace Good Ground. Here, band members are shown after playing at the unveiling of the Hampton Bays World War I Memorial, which was dedicated by longtime summer resident Gov. Alfred E. Smith. (HBS.)

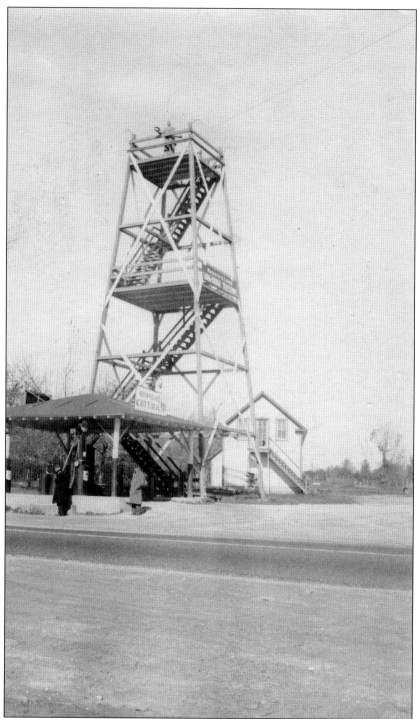

THE BAUSCH & LOMB LONG-RANGE TELESCOPE AND TOWER, C. 1920. It is unclear where this unusual viewing tower was built; however, the most likely location is in the village center. Atop the tower is a long-range Bausch & Lomb telescope that visitors could use to view Shinnecock Bay in one direction and Great Peconic Bay in the other. (HBS.)

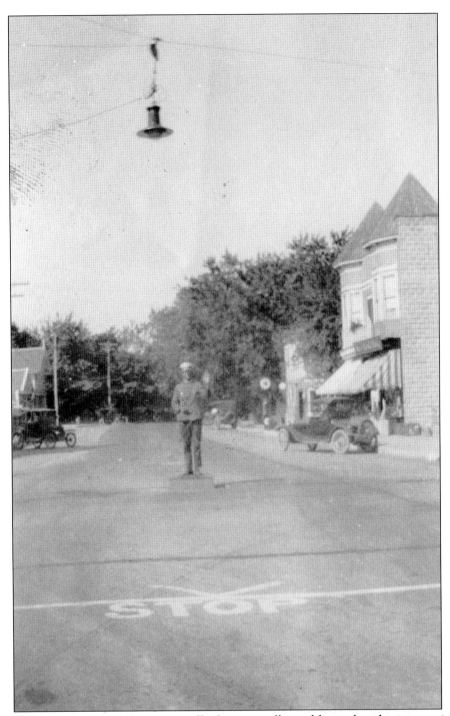

JOHN H. SUTTER, C. 1920. Directing traffic from a small stand located at the intersection of Montauk Highway and Ponquogue Avenue is the chief of the Hampton Bays Police Department, John Henry Sutter (1877–1954). It is hard to believe that Hampton Bays ever had a police department, but it did, and Sutter—a former vaudeville actor—was appointed in 1922 and served until he retired in 1948. He was succeeded by Sidney Warner. (HBS.)

THE HAND ALDRICH AMERICAN LEGION NO.
924 BUILDING, 1930s. Located on Ponquogue
Avenue, this building was the fifth site occupied
by the Legion, which purchased the property and
completed the structure in 1928. It is named for
Eugene Hand (World War I) and Sgt. John E.
Aldrich (World War II). In front of the standing
men is one of two World War I memorials erected
in Hampton Bays, the other being located on
the grounds of St. Rosalie's Church. (HBS.)

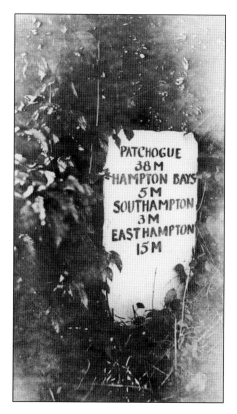

SOUTH FORK MILESTONES, 1931. While postal
mile markers were installed on the North
Fork in 1755, it took another 10 years for a
similar route to be laid out on the South Fork.
This image depicts one of the old South Fork
milestones located east of Hampton Bays, near
the Seagull Inn in the Shinnecock Hills. (ST.)

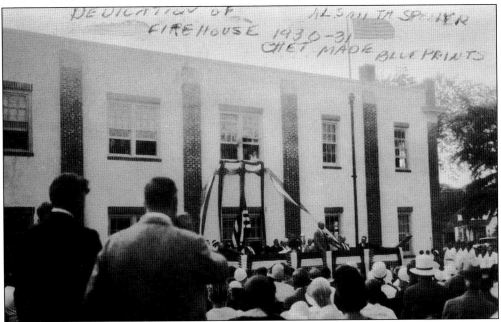

DEDICATION OF THE FIREHOUSE, 1931. It took until 1930 for the Town of Southampton to authorize a fire department in Hampton Bays. Gov. Alfred E. Smith, who had long summered in the village, dedicated the firehouse on September 5, 1931. The original building pictured here was expanded in 1965 and again in 1982. (HBS.)

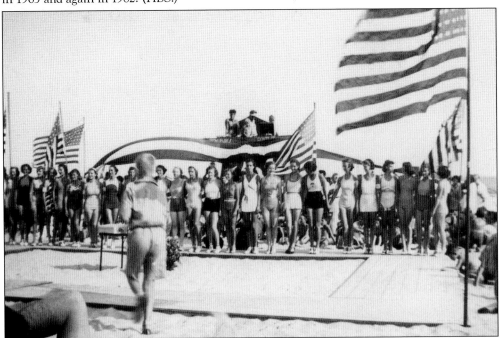

MISS HAMPTON BAYS CONTEST, C. 1936. This contest was first organized in 1935 for the benefit of the lifeguard fund. The following year, the contest was held down on the beach, and the winner was Mae Martin, who was christened Miss Hampton Bays. The competition continued as part of the Miss New York Pageant through at least 1965. (HBS.)

HAMPTON BAYS PARADE FLOAT IN SOUTHAMPTON, c. 1940. After the 1938 hurricane opened up the inlet, there was a great deal of discussion on whether to close it up or leave it open. This float from Hampton Bays, which was featured in a Southampton parade (perhaps at the 300th anniversary celebrations), noted the need to make a decision about what should be done. (HBS.)

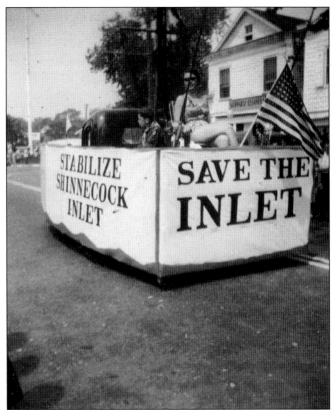

WORLD WAR II MEMORIAL, c. 1947. Erected on the site of Balzarine's restaurant, the World War II Memorial would stand for just a few years before it was moved down between two of the commercial buildings farther west on Main Street. Like so many others, it eventually became a burden and was consigned to the town dump—a sad end to a monument meant to honor those who gave their lives in defense of the country and the defeat of totalitarianism. (HBS.)

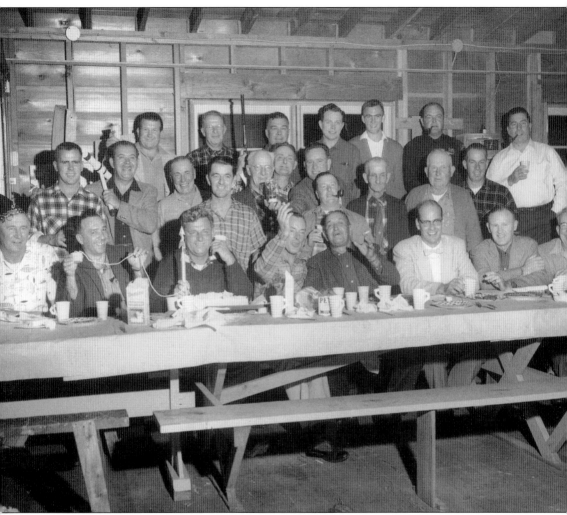

HAMPTON BAYS ROD & GUN CLUB, 1950s. Little is known about the rod and gun club, which brought together men of many different ages who were interested in the hunting and fishing activities long associated with Hampton Bays. This photograph, likely taken in celebration, shows a gentleman (at center) holding up a small trophy. Among those pictured are Bud Downs, Chet Downs, Frank Downs, Fletcher Warner, Ted Jankowski, Ed Warner, Murray Phillips, John Businah, and Sidney Warner. (HBS.)

Two

HOTELS AND BOARDINGHOUSES

The arrival of the Long Island Railroad in 1869 opened up the east end of Long Island to the many wealthy families that lived in New York, Kings, and Queens Counties. While villages and hamlets from Southampton east tended to be populated by those who lived in Manhattan, the North Fork of Long Island, along with Hampton Bays, tended to pull people from Brooklyn and Queens. The *Brooklyn Daily Eagle* newspaper became a favorite advertising spot for the hotels and boardinghouses that came to dominate the hostelry industry of the community. While locals tended to dominate this type of business, as interest grew in Hampton Bays as a vacation spot, more outside investors constructed and opened larger and larger hotels. By the early 20th century, there were dozens of boardinghouses and hotels operating each season. The coming of the automobile would sound the death knell for the industry—why travel locally when one can travel far? Today, almost none of the great vacation-era structures remain standing; most either were lost to fire or were abandoned to their fates.

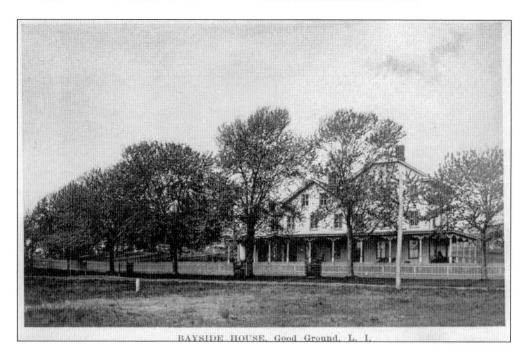

BAYSIDE HOUSE, Good Ground, L. I.

BAYSIDE HOUSE, 1900s. Bayside House was located on the west side of Tiana Bay and was one of the earliest boardinghouses located near Hampton Bays. Sidney C. Bellows operated it since at least 1879, and in 1891, he had advertisements for the following: "Surf and still water bathing, boating" and "free sail to surf bathing station daily." By 1900, other activities, including "good driving, cycling, tennis, [and] croquet," were also available. The Bayside House continued in operation under William L. Bellows until 1932. It was purchased in 1946 and was operated by Martha Burke. It eventually became a club and discotheque. It was still standing in 1983. (Both, HBS.)

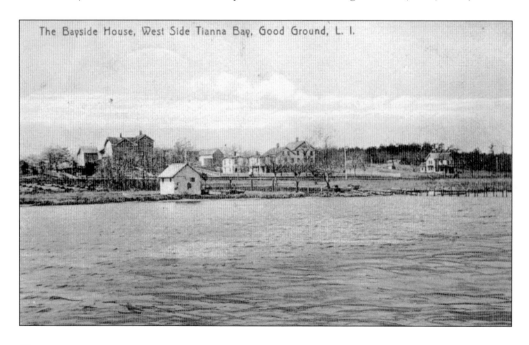

The Bayside House, West Side Tianna Bay, Good Ground, L. I.

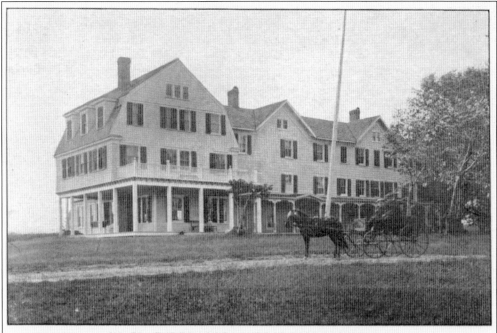

NO. 75. THE BELLOWS HOUSE AT GOOD GROUND, L. I.

BELLOWS HOUSE, 1900s. Located on Rampasture Road along the east side of Tiana Bay, the Bellows House was operated by Edwin C. Bellows from the 1890s through the early 1920s. The Bellows House was known for a masked ball held there to close the season of 1910, where the owners won "great praise for the manner in which the dance was conducted." During World War I, guests helped with the war effort, "doing Red Cross work for [the] St. Stevens Branch of Catholic Women's Civic and Social League of Brooklyn." After being closed for several seasons, the Bellows House was destroyed by fire on the night of Wednesday, May 14, 1930. (HBS.)

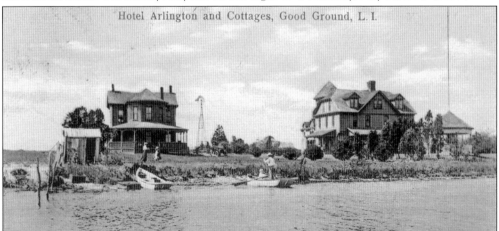

Hotel Arlington and Cottages, Good Ground, L. I.

THE ARLINGTON AND COTTAGES, 1900s. Constructed in 1890, the Arlington boardinghouse was one of the more popular spots to stay in Hampton Bays. Owned by Leverett Squires, it was located near the mouth of Smith's Creek and was improved in 1907 by the addition of an annex. At one time, it also offered separate cottages to guests. A bowling alley on the property was an unusual feature for the period, but due to the complaints of a neighbor, Henry Donald, it was never put into use. The main building was demolished in 1973 or 1974. (HBS.)

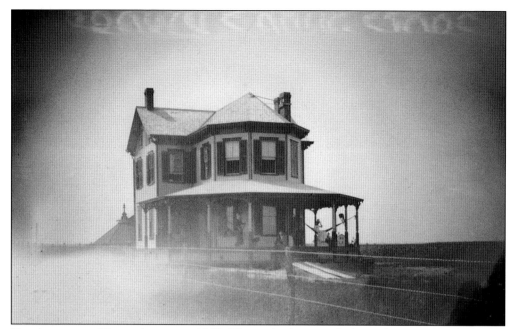

THE ARLINGTON HOUSE ANNEX, C. 1908. This early photograph shows the annex not long after it opened. Just beyond the house, the roof of the elegantly designed icehouse can be seen. The annex was demolished in November 1940. (HBS.)

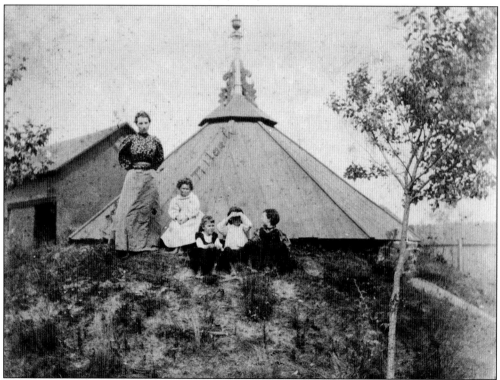

THE ARLINGTON HOUSE ICEHOUSE, 1900S. The icehouse behind the Arlington Annex was fairly elaborate for the day, with a very decorative rooftop spire. (HBS.)

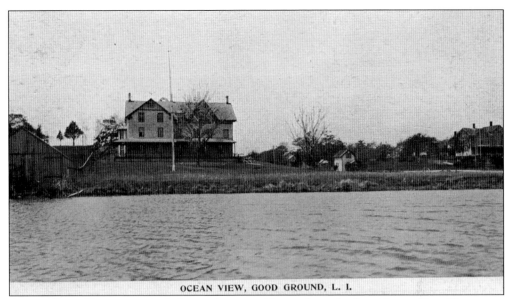

OCEAN VIEW, GOOD GROUND, L. I.

OCEAN VIEW HOUSE, C. 1905. Located in west Tiana along the bay, Ocean View House was "beautifully situated on high ground" and was known for its "excellent table." The proprietor was Warren Corwin, and his establishment was a successful one. In 1890, he noted in one of his advertisements that his establishment was located in a "healthy locality" with "no malaria." Later operated by Otis M. Corwin of Brooklyn, the boardinghouse burned to the ground, with a loss upwards of $15,000, on Monday, May 1, 1916. (HBS.)

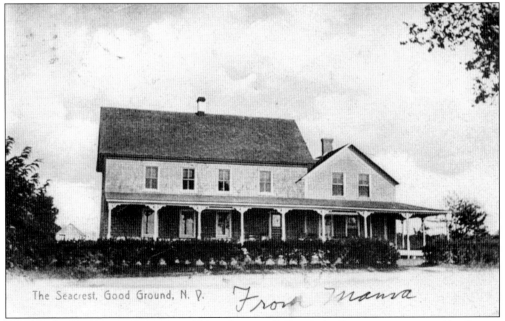

The Seacrest, Good Ground, N. Y.

THE SEACREST, C. 1907. Opened in 1904 on Springville Road, the Seacrest was operated by George A. Lane and could accommodate up to 30 guests. Unlike many other boardinghouses in the area that occupied older, renovated buildings, the Seacrest was noted as being a "new house." It was still in business as late as 1917, when it was noted that "Mr. and Mrs. Frank Halsey of Brooklyn" were guests. Later converted into apartment rentals, the building still stands today. (HBS.)

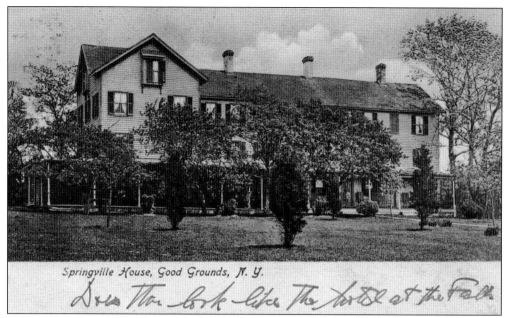

Springville House, Good Grounds, N. Y.

Dres This look like The hotel at the Falls

SPRINGVILLE HOUSE, C. 1915. Located along Smith Creek adjoining the Gilsey Estate, Springville House included a spacious five acres of landscaped grounds and "a yacht for excursion parties." Opened by 1882, the boardinghouse was originally operated by William N. Lane (1840–1915) and was known as Lane's Sportmen's Retreat. A market gunner and professional guide, Lane accommodated gunning parties during the season. (HBS.)

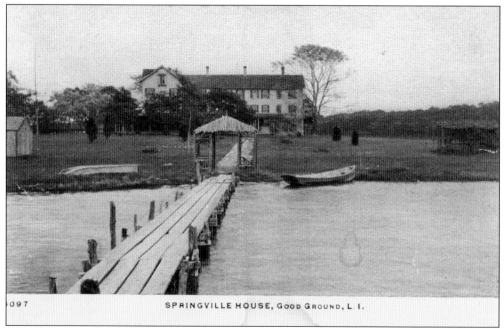

097 SPRINGVILLE HOUSE, GOOD GROUND, L. I.

SPRINGVILLE HOUSE, C. 1908. This image shows the dock stretching out into Smith Creek, opposite Rampasture Point. A number of improvements had been added to the property by 1926, including a bowling alley and dance hall. Still in operation the following year (1927), it would be among the last of the resort-era hotels to close its doors. (HBS.)

32

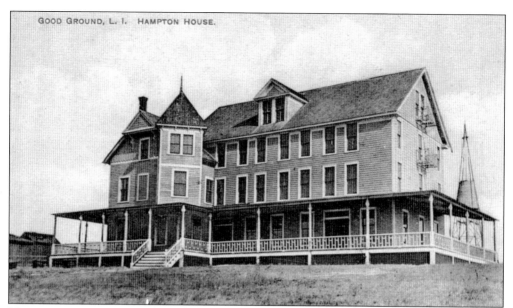

HAMPTON HOUSE, C. 1908. Hampton House, which was located on the east side of Tiana Bay, opened sometime around 1902, and by 1904, E.W. Williams managed it. He listed it as accommodating 75 guests. The hotel, which was tastefully furnished, operated from June 1 through October 1 and had 40 rooms available to the public. Still in operation in 1916, it was later converted into the home of William C. Lesster and was named Grace Crest. At that time, one of the upper floors was removed. (HBS.)

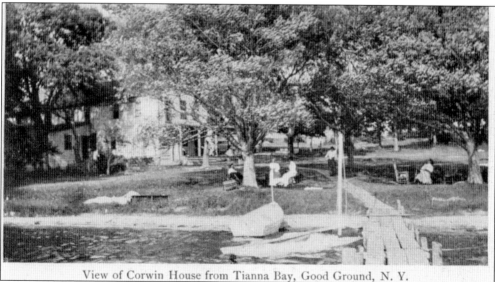

View of Corwin House from Tianna Bay, Good Ground, N. Y.

VIEW OF THE CORWIN HOUSE FROM TIANA BAY, C. 1910. One of the older boardinghouses in Hampton Bays, Corwin House, operated by George E. Corwin, was in operation from at least 1887, when the family of the late president Ulysses S. Grant stayed there that summer. Local papers noted, "Our place is honored with the presence of late Gen. Grant's son and family," further stating that the son appeared to be wandering the Shinnecock Hills "for the purpose of building a summer cottage." The Corwin House, which called itself the "oldest resort house on Shinnecock Bay," was still in operation as late as 1936. (HBS.)

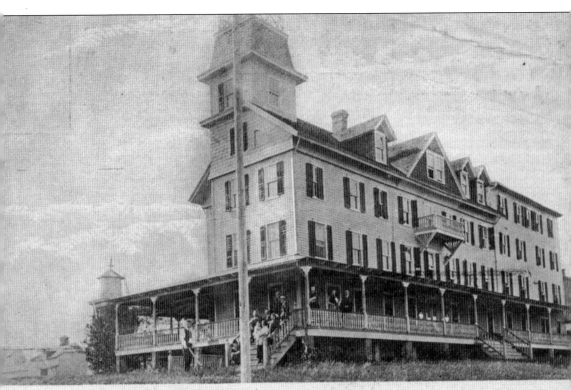

CLIFTON HOTEL, GOOD GROUND, L. I.

THE CLIFTON HOTEL, C. 1910. The largest of the grand hotels built in Hampton Bays, the Hotel Clifton was owned by a Captain Phillips and was completed in 1889 just north of Ponquogue Point, with David Meschutt taking charge of the management. The hotel, which had many managers during its history, had its own private stage line to bring guests to the site. Then, proprietor C.D. Vail announced plans in 1895 to install systems to "furnish water for the hotel; steam heat and a dynamo" for electricity. In 1911, the building was acquired by Paul C. Grening and opened in 1912 as the Hotel Grening; however, the Clifton name was restored the next season. The hotel was renamed the Del Monte in 1922. The huge structure with its 60 rooms was closed not long before it was destroyed by fire on March 1, 1925. (HBS.)

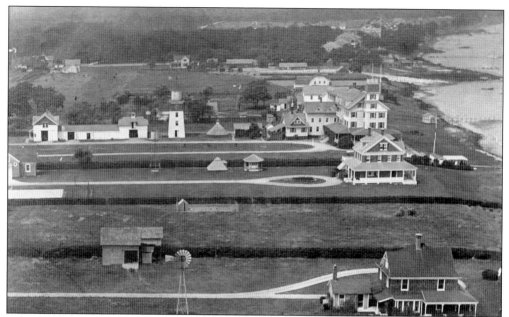

CLIFTON HOTEL FROM THE BACK, C. 1910. During its heyday, the hotel grounds included two tennis courts, a huge barn and stable complex, a large dock, and at least 30 bathhouses. (HBS.)

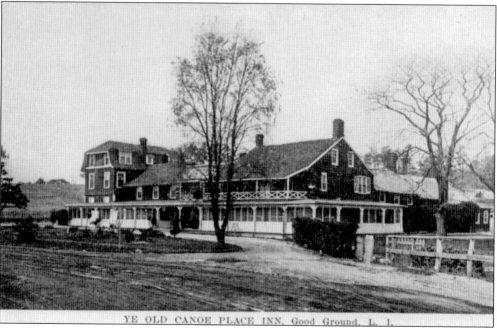

YE OLD CANOE PLACE INN, Good Ground, L. I.

THE OLD CANOE PLACE INN, C. 1920. The Canoe Place Inn—the most famous of all Hampton Bays hostelries—had its origins in the stagecoach stop built by Jeremiah Culver in 1750. It became a popular resting place and was slowly enlarged over the next 150 years. In the early 20th century, the inn was sold to Ernest A. Buchmuller, whose family continued its operation until they sold it in 1917. The buyer, Julius Keller, was the famed owner of Maxim's in New York City. Just four years after he purchased the inn, on July 5, 1921, it was destroyed by fire, with two lives lost in the blaze. (HBS.)

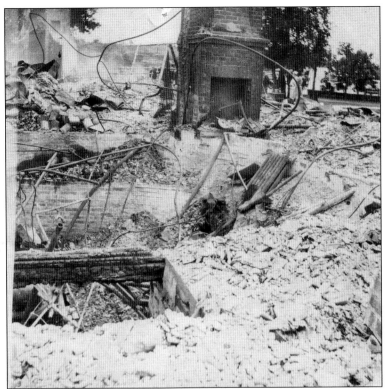

PART OF THE REMAINS OF THE CANOE PLACE INN, JULY 1921. The bodies of the two people who died in the fire—Richard Heineman (an employee) and Florence Whittington (a guest)—were discovered in the ruins after the fire was extinguished. The damage to the hotel, which was a total loss, was put at $30,000. (HBS.)

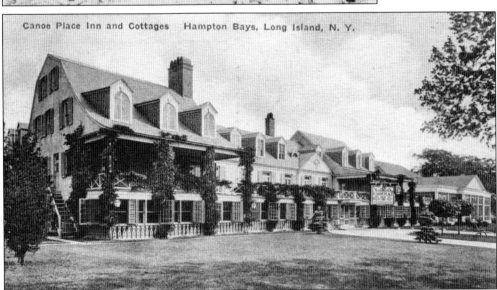

Canoe Place Inn and Cottages Hampton Bays, Long Island, N. Y.

CANOE PLACE INN AFTER REBUILDING, C. 1923. To rebuild the inn after the fire, Keller hired noted Gold Coast estate architect William Lawrence Bottomley (1883–1951). Bottomley was no stranger to the area, his family having built a summer home in Water Mill and he having designed the new Southampton High School in 1912. The new building included an enormous dancing pavilion, 34 bedrooms, a lounge, and 20 bathrooms. Keller also added a number of cottages to the west of the inn, one of which was the longtime vacation home of New York governor Alfred E. Smith (1873–1944). (HBS.)

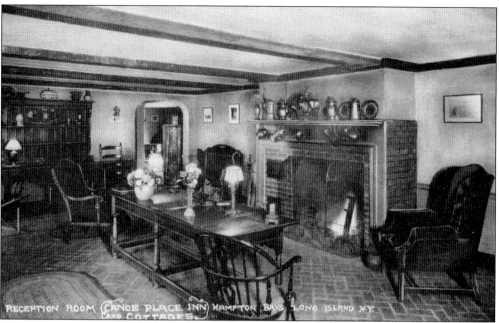

RECEPTION ROOM AND DINING TERRACE, C. 1923. When the new inn was completed, the magazine *Architectural Record* noted that the owners of the inn showed "a respect for a fabric so closely identified with local history" in rebuilding, while the architect was sympathetic to the "qualities that gave the inn its unique character," with the final product being "an independent play of imagination refreshing and felicitous in its expression." (Both, HBS.)

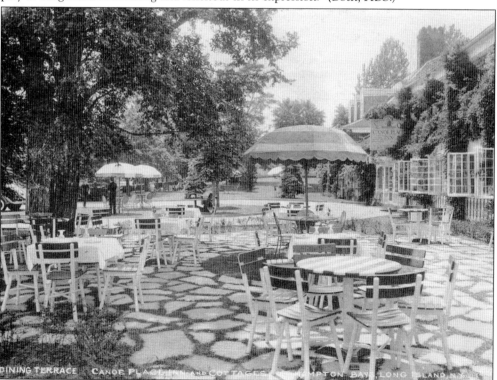

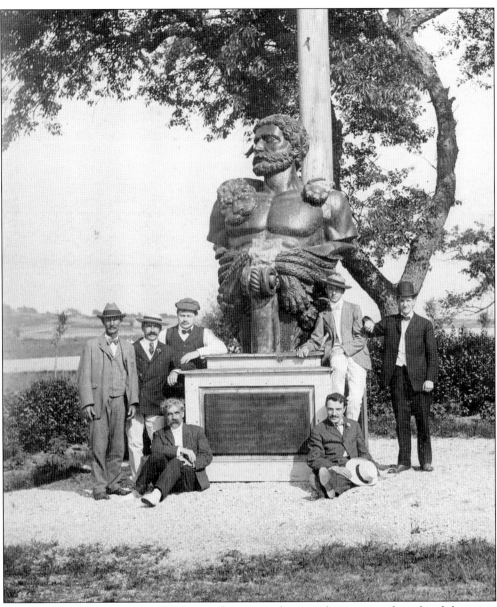

Posing with *Hercules*, c. 1915. Located opposite the inn, the amazing figurehead depicting Hercules was made for the USS *Ohio* and carved by the firm of Dodge and Sharpe in New York City for the princely sum of $1,500. The *Ohio* was built in 1817 in the New York Navy Yard and launched on May 30, 1820. In 1838, the vessel acted as the flagship under Commodore Isaac and, later, sailed in the Gulf of Mexico and Pacific Ocean. In 1883, the ship was sold to Isaac Snow of Rockland, Maine, who in turn sold it to a group of investors from Greenport, and the *Ohio* was towed to Greenport Harbor where it was stripped of its fittings and eventually dynamited. The figurehead was sold for just $10 to John Aldrich of Aquebogue. He sold it for $25 to Miles Carpenter, who placed it opposite the Canoe Place Inn, where it was a sight to behold for over 60 years. Local legend had it that a girl who could climb up the statue and kiss *Hercules*'s cheek would be married within a year. Patrons from the Canoe Place Inn loved to pose with the statue. (HBS.)

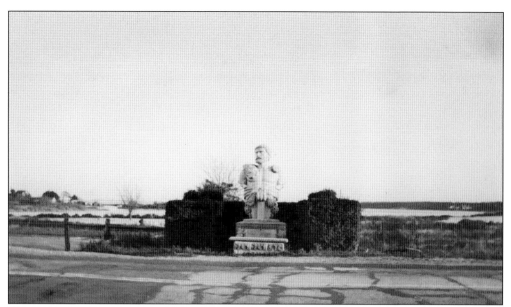

HERCULES SHOWN ALONG THE ROAD, 1930S. The precarious position along Montauk Highway made the figurehead difficult to protect. In one example, just after it had been repainted, a careless road crew splashed the figure with oil, ruining the paint job. (HBS.)

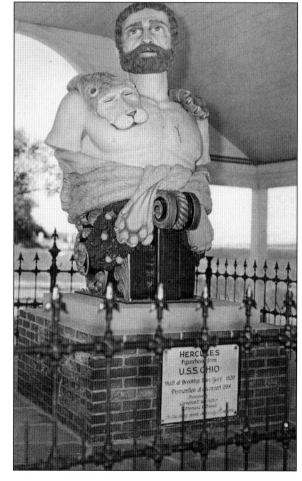

HERCULES RESTORED, 1970S. Shoe magnate Ward Melville (1887–1977) acquired the figurehead and moved it to Stony Brook, Long Island, where he had redeveloped the entire village. It was restored and placed under a protective canopy along the water where it remains to this day. (HBS.)

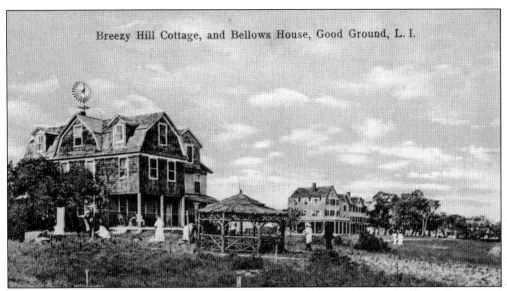

Breezy Hill Cottage, and Bellows House, Good Ground, L. I.

BREEZY HILL COTTAGE, C. 1915. The home of Henrietta and A. Alonzo Bellows, Breezy Hill Cottage was one of the smaller boardinghouses located closer to the highway. The income it produced allowed the future locally well-known doctor, Emma Bellows, to go to medical school. Abandoned for many years, it was finally burned by the Hampton Bays Fire Department on October 6, 1957. (HBS.)

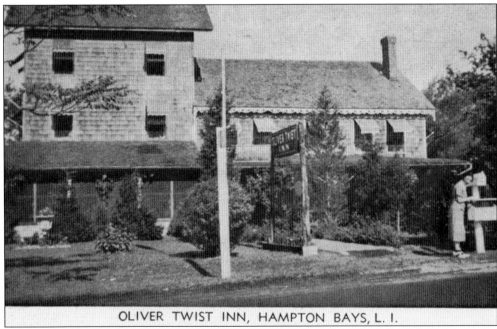

OLIVER TWIST INN, HAMPTON BAYS, L. I.

OLIVER TWIST INN, 1930S. First opened as the Foster House by A.M. Foster, from 1922 to 1939, the Oliver Twist Inn was operated by Stephen Oliver (1876–1939), a native of Vienna, Austria, and was noted as having the "breeziest spot on the Ocean, near [the] old lighthouse." Advertisements for the inn noted that it offered "German home cooking" with rates of "$25 weekly." Purchased by Paul Zorland and Robert Flemming in 1953, the inn continued as a restaurant and nightclub through at least 1955. Not long after, it was destroyed by fire. (HBS.)

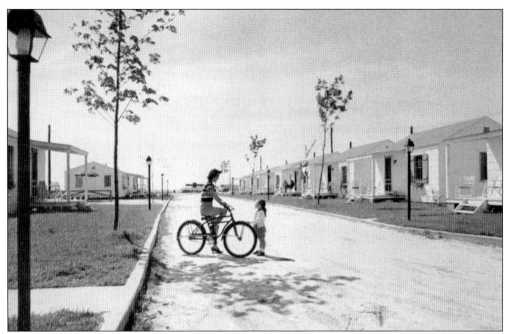

THE SKIPPER'S COTTAGES, C. 1958. Located on Shinnecock Bay, the cottages were completely equipped for individual living and were available by the week, month, or season. Advertisements noted that the cottages featured "excellent swimming, fishing, and boating directly at the doorstep." (Author.)

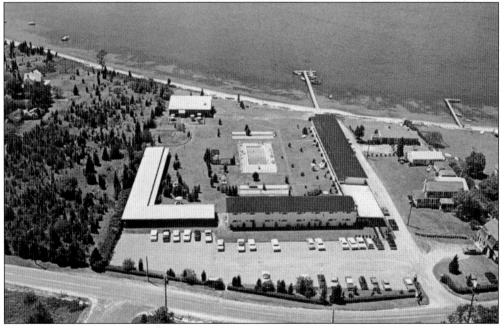

TIANA BAY MOTEL, C. 1957 ADVERTISEMENT AND C. 1970 POSTCARD. The Tiana Bay Motel was opened in 1957 on Rampasture Road, replacing Midfield, the Charles Gorham Hedge Estate. It featured carpeting installed by the Sybelle Carpet and Linoleum store of Patchogue, New York. A total of 52 units were available for rent, including single, double, and triple rooms. (HBS.)

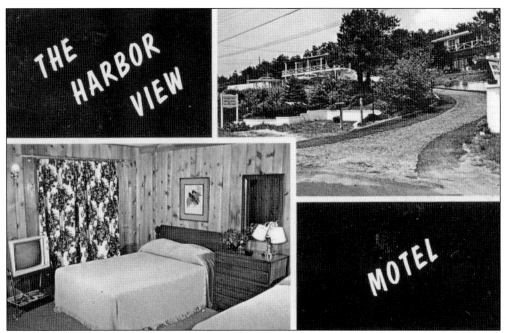

HARBOR VIEW MOTEL, 1970s. Located in the Shinnecock Hills, the motel included regular rooms in addition to efficiency apartments with panoramic views of the "bay, ocean, and inlet." Ruth and Tom Fitzpatrick operated it. (Author.)

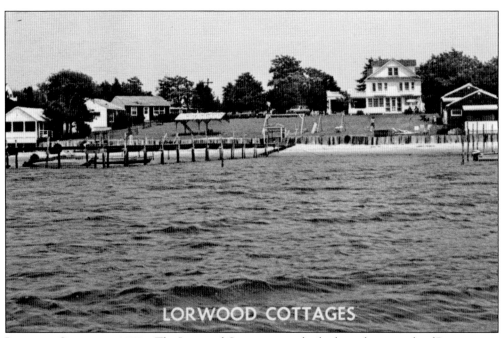

LORWOOD COTTAGES, 1970s. The Lorwood Cottages were built along the east side of Rampasture Point overlooking the bay. They were erected during a period when many visitors were coming to Hampton Bays by automobile. (Author.)

Three

ESTATES AND SUMMER HOMES

All of the Hamptons enjoyed the construction of fabulous estates. Many local residents of Hampton Bays worked for the summer estate owners—in one way or another—while still many more worked on the estates that stood throughout both Southampton and East Hampton towns. Most were built by titans of industry, finance, shipbuilding, and the like. In Hampton Bays, estates were constructed, however, by a different group that would make the village its summer playground. Most the estate owners were friends and associates who were involved in the political machinations of Tammany Hall in New York City. Tammany Hall dominated Democratic politics in New York from the period of the Civil War all the way up into the 1930s. The summer estate owners of Hampton Bays played important roles at Tammany, whether it was Municipal Court judge Wauhope Lynn, New York State Supreme Court justice Morgan J. O'Brien, Commissioner of Utilities Nicholas J. Hayes, or Fire Commissioner Richard Croker. Their influence could be felt wherever they went. This was indeed true in Hampton Bays, where these men, both together as well as on their own, tried to reshape the community and transform it into a summer paradise.

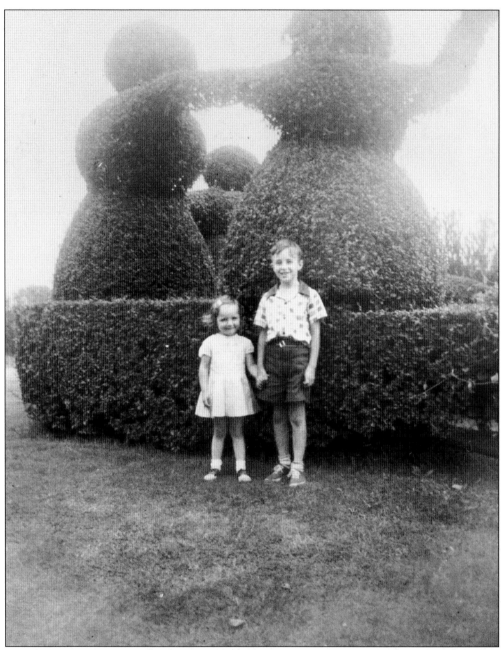

THE JACKSON CHILDREN OF HAMPTON BAYS IN FRONT OF THE "DANCING LADIES," C. 1950. Walter "Bud" Jackson and his sister Peggy stand in front of the famous dancing women sculpted hedges located in nearby East Hampton. Their grandfather, Henry Miller, like so many of the residents of Hampton Bays, made his living as a gardener in East Hampton, and his two grandchildren are pictured in front of one of the famous landmarks he took care of. (WRJ.)

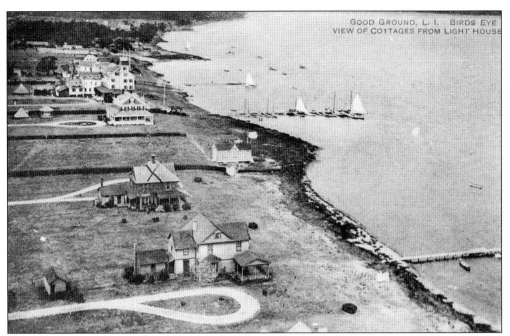

PONQUOGUE POINT FROM THE AIR, 1900S. Shot from the top of the lighthouse looking north, this photograph shows some of the summer homes of many of New York's wealthy families. The huge Clifton Hotel is seen in the far left background. (HBS.)

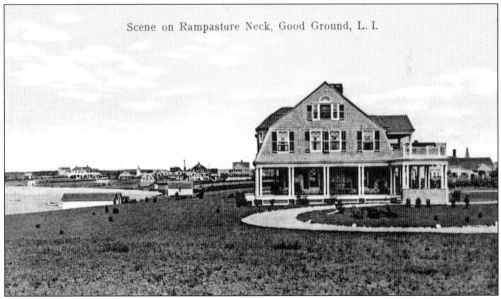

Scene on Rampasture Neck, Good Ground, L. I.

SCENE ON RAMPASTURE NECK, HAMPTON BAYS, 1900S. Summerhouses fill the shoreline in this image. The peninsula known as "Rampasture," located south of the hamlet, was originally used for the pasturing of sheep. This view has to be looking north, with many summer homes and their boathouses located along Tiana Bay to the left. The Shingle Style home in the foreground—one of many constructed of similar design in Hampton Bays—may be the summer residence built between 1890 and 1891 by Fred W. Jackson for the Horgan brothers of New York. (HBS.)

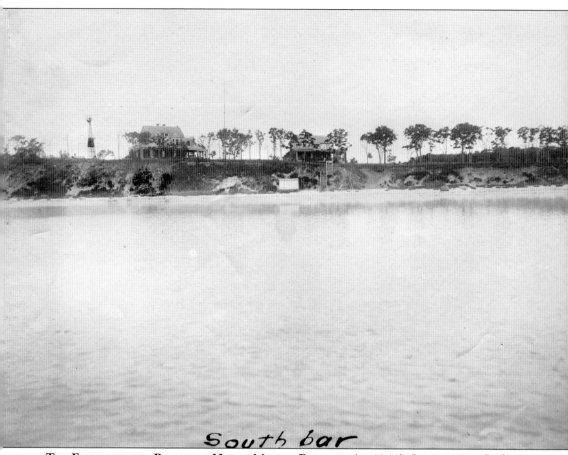

South bar

THE ESTATE OF THE REVEREND HENRY MERLIN BARBOUR (B. 1848), LATE 1890S. Barbour—whose house is shown at the right of this image—was a graduate of Trinity College, located in Hartford, Connecticut, and received a master of arts degree from the college in 1873. He served as an Episcopal minister at the Trinity Church of Madalin, New York, from 1872 to 1874; the Trinity Church of Woodside, Newark, New Jersey, from 1874 to 1876; and the Trinity Church of Trenton, New Jersey. His daughter Katherine Hutchinson Barbour, who was one of 15 children, was married on the estate grounds in October 1902. The property that the house sits upon was once part of the holdings of Sarah Southgate, one of the only female developers from Hampton Bays, whose home Shorebluff is shown at the left. Southgate named her development Southbar, in honor of herself and her neighbor Rev. Barbour. (HBS.)

LYNNCLIFF, L. I.

LYNNCLIFF, C. 1910. This is the estate of Judge Wauhope Lynn (1856–1920). Lynn was a self-made man, born in Ireland, trained as a mechanic, and later becoming a lawyer, district attorney, assemblyman, and municipal court judge. His estate, constructed in 1892, was one of the earliest in the area to have electricity, which was provided by an engine on the grounds. He convinced the town to move Canoe Place Road back from the shore, so that the waterfront property could be developed, and in 1911, he acquired property along Squiretown Road for the erection of a Marconi wireless tower. At a time when many local property owners forbade hunting on their properties, Lynn was among the first residents in Hampton Bays to open his properties to unrestricted hunting. Lynn died at his home in Hampton Bays in 1920, and by the 1970s, the residence was demolished. The Lynn family name survives in the names of several developments and streets in the village. His brothers also had estates along present-day Lynn Avenue: John Lynn's was named Linndon, and Harry Gordon Lynn's was named Lynnview. (HBS.)

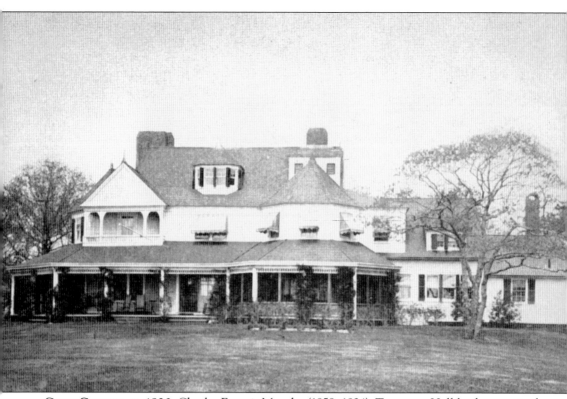

GOOD GROUND, C. 1920. Charles Francis Murphy (1858–1924), Tammany Hall leader, acquired his estate in 1904. At the time, it was rumored that Murphy spent $60,000 for the property, which included 110 acres and a home that was constructed in 1881. At its height, Murphy's West Tiana estate grew to nearly 500 acres. He made his money through his political connections and his long association with the New York Contracting and Trucking Company. These connections allowed the company to receive enormous city contracts and to operate "practically free from competition." Murphy died on April 25, 1924, and was buried in Calvary Cemetery. His estate was destroyed by fire in 1936, and in 1953, the land was purchased for the development named Tiana Shores. (GT.)

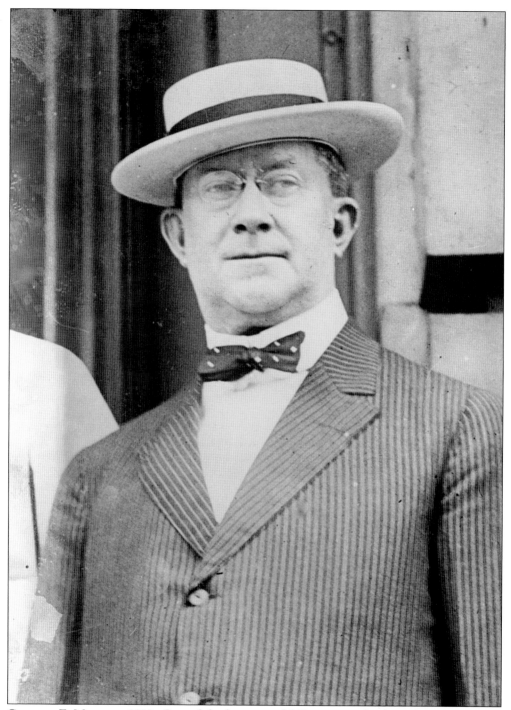

CHARLES F. MURPHY, 1912. One of the last powerful Democratic leaders of Tammany Hall, Murphy made his initial fortune by operating a number of saloons in New York City, even though he was known personally as a teetotaler. (LOC.)

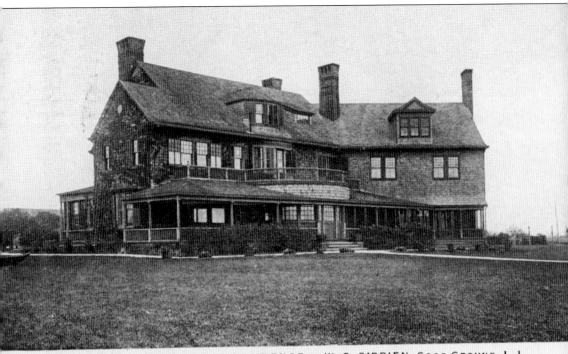

"ROSE CREST", RESIDENCE OF W, G. O'BRIEN, GOOD GROUND, L. I.

ROSECREST, C. 1910. The summer residence of Judge Morgan J. O'Brien was located along Wells Creek, not far from the Ponquogue Lighthouse, and was built before 1894. The home was the site of the wedding of the judge's daughter Genevieve to E. Lyttleton Fox in 1905. The large shingled mansion was eventually traded by O'Brien to Albert E. Boardman for his property Villa Mille Fiore, located on Great Plains Road in Southampton. Rosecrest was then donated, in 1921, to the Dominican Sisters of the Sick and Poor of the Convent of the Immaculate Conception on Sixty-second Street in New York City to be used as a retreat center. The year prior, in 1920, the sisters had purchased other land in Good Ground from O'Brien. By 1960, the mansion had been condemned, and only part of the once grand home was salvaged and moved to another part of the estate grounds. This portion was still standing as late as the early 1980s. (HBS.)

MORGAN J. O'BRIEN, 1900s. Judge Morgan J. O'Brien (1852–1937) was born in New York City and attended St. John's College, St. Francis Xavier's College, and Columbia University. A popular jurist who saw service in nearly every branch of the legal system, he eventually served as one of the justices of the New York State Supreme Court. O'Brien was described as having a "winning nature." His home in Hampton Bays, Rosecrest, was probably named for his wife, the former Rose M. Crimmins, with whom he had nine children. (LOC.)

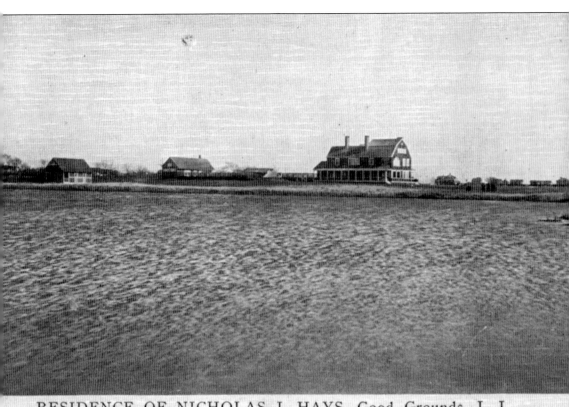

RESIDENCE OF NICHOLAS J. HAYS, Good Grounds, L. I.

RESIDENCE OF NICHOLAS J. HAYES, C. 1915. Located on Penny Lane overlooking Penny's Pond, the mansion was supposedly designed by noted American architect Stanford White. The home had once been the property of Judge James Carter and before him the site of the south side sawmill. Like so many other estate owners in Hampton Bays, Hayes (1856–1928) made his money through his service in a number of political positions, including New York City's commissioner of utilities, sheriff, and fire commissioner. Hayes first began summering in Good Ground around 1907, and when he died in 1928, he was buried in Calvary Cemetery, located in Woodside, Queens, New York. The Penny Point Motel was later built nearby the home, which still stood as of the early 1980s. (HBS.)

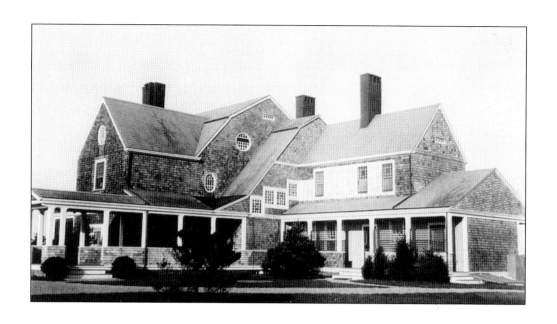

SEABOURNE, THE WILLIAM G. MORRISEY JR. ESTATE, 1930s. American actress Nora Bayes (1880–1928) purportedly acquired the Hayes estate and owned it until her death in 1928. However, she died before Hayes did, so this may not be accurate. The house was then acquired in the mid-1930s by the Morrisey family of Brooklyn, who were involved in the real estate business. In 1950, William G. Morrisey Jr. and his wife, Mildred Lynn Morrisey, owned the 55-acre estate. They were involved in an unusual suit over the ownership of Penny's Pond in Hampton Bays with the Town of Southampton, which eventually won the suit and ownership of the pond. (Both, HBS.)

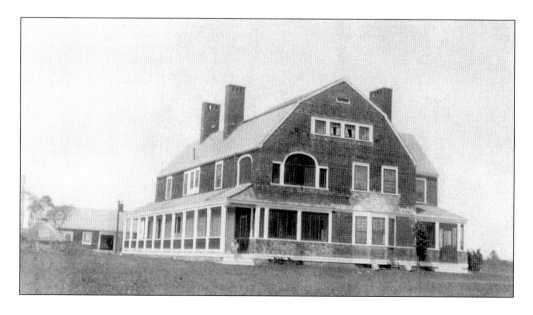

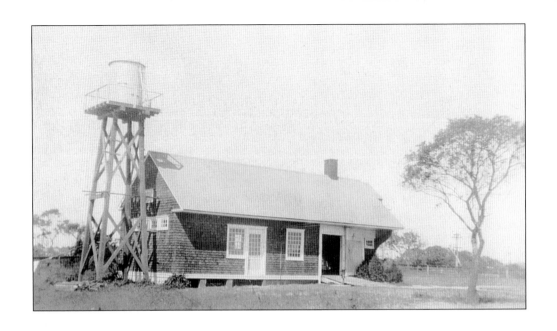

BEFORE AND AFTER PHOTOGRAPHS OF SEABOURNE GARAGE, 1936. The original garage on the Morrisey estate was found to be inadequate for the family, and so in 1936 it was rebuilt in a much grander style. Even with all the work, the water tower at left remained intact. (Both, HBS.)

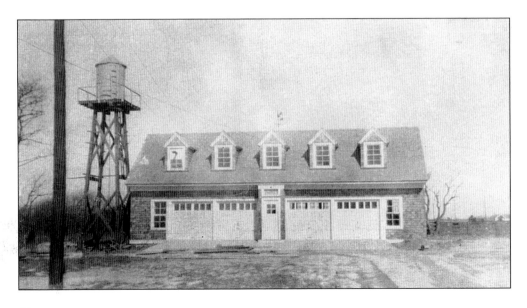

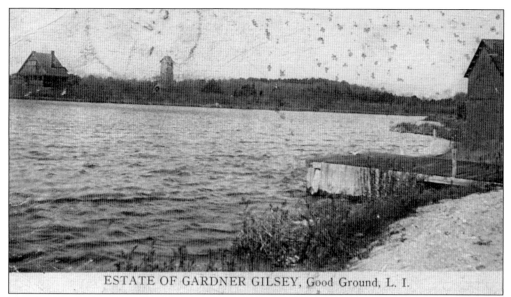

ESTATE OF GARDNER GILSEY, Good Ground, L. I.

The Box, the Estate of John Gilsey, c. 1915. John (d. 1907) was the son of Peter Gilsey (1848–1901), one of the heirs to the Gilsey estate in Manhattan, which included properties such as the Gilsey House on Twenty-ninth Street and the Fifth Avenue Theater. The Gilsey property, located along the east side of Smith Creek, included a number of homes and outbuildings. This Swiss Chalet–style house was built on that property for John and his wife, Evaleen (d. 1909). Following their deaths and the death of his mother, John's brother Gardner Ladd Gilsey (1878–1956) inherited the property. (HBS.)

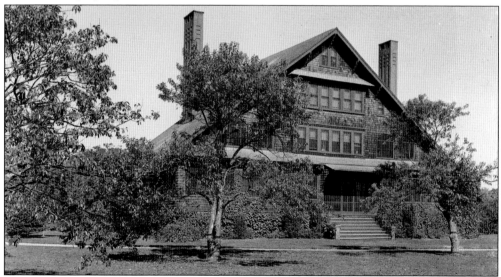

Gardner Gilsey's Estate, 1950s. Much of the Gilsey family fortune was lost during the 1929 stock market crash, and Gardner moved to another property in Southampton. He continued in the family business, real estate, establishing an office in Southampton village under the name Gardner Gilsey & Co. The house was purchased by Dr. Leonore N. Carlisle and occupied by her until her death in 1944. The property was known during the 1950s as the Clancy estate. Eventually, the Hampton Bays property was subdivided and became the development Old Harbor Colony. The main house still stands today, located along Nautilus Drive. (HBS.)

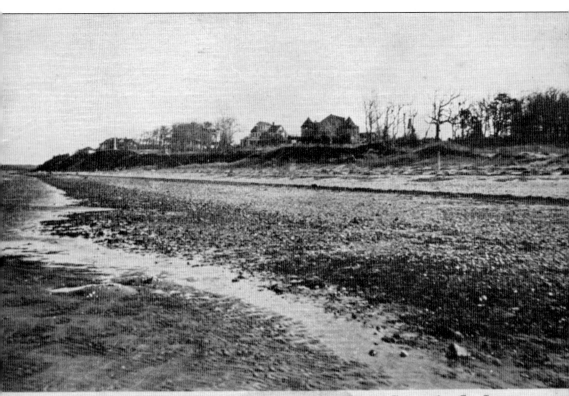

COTTAGES ON PECONIC BAY. Good Grounds. L. I.

COTTAGES ON PECONIC BAY, C. 1915. In 1896, Sarah Southgate developed this area located along the north side of Newtown Road. The houses that can be seen in this image are, from far left to right, Hardy Hall, with the flagpole; the Disbrow estate; and the Deming house. The name of Disbrow will forever be associated with the suspected murder of Charles T. Foster and Sarah Ray "Dimple" Lawrence of Good Ground by their acquaintance Louis A. Disbrow. He was the son of Thomas A. Disbrow of Richmond Hill, Queens, Long Island, who was an executive in the fertilizer business. After a lengthy trial, Louis was acquitted of the charges in January 1903 and returned to a somewhat normal life. (GT.)

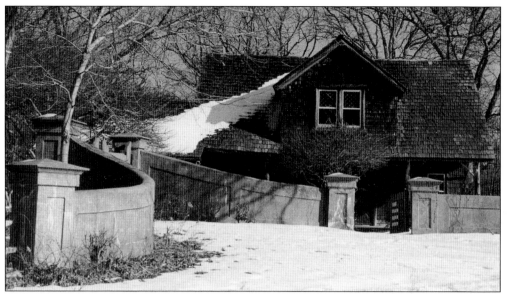

ENTRANCE TO THE HARDY ESTATE WITH THE GATEHOUSE, NEWTOWN ROAD, 1999. Charles J. (d. 1956) and Virginia Taylor (d. 1956) Hardy built this summer estate in Hampton Bays around 1907 and named it Hardy Hall. The estate, which ran from Montauk Highway all the way to Peconic Bay, included 193 acres. Hardy, who was chairman and president of the American Car and Foundry Company from 1899 until 1951 and owner of the *Nyack Journal News*, is best remembered locally as the husband of Virginia, the woman who constructed St. Mary's Episcopal Church, parish house, and rectory in Hampton Bays. (HBS.)

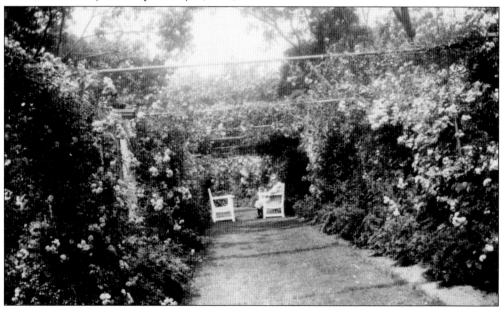

THE ROSE GARDEN AT HARDY HALL, 1930S. The extensive grounds of the Hardy estate were opened to the public for a garden tour in July 1940 and served as the location where afternoon tea was held. Once one of the grandest homes in Hampton Bays, the estate was abandoned after the deaths of Mr. and Mrs. Hardy and suffered from vandalism until it was destroyed by fire in November 1973. (PPL.)

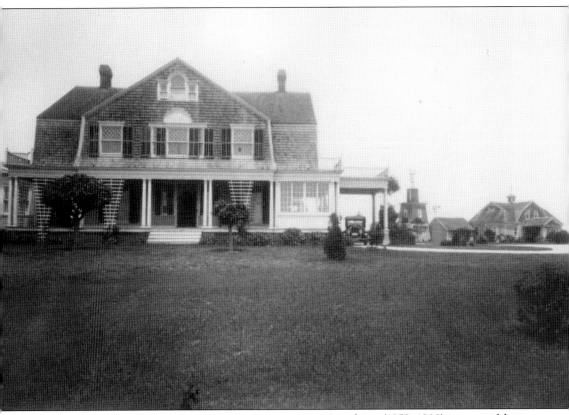

LOUGH REA, THE DANIEL S. LOUGHRAN ESTATE, 1901. Loughran (1859–1909) was a wealthy iron founder and banker from Brooklyn, Long Island, who served as the president of the Kings County Ironworks. As a young man, he was interested in the mining operations located in Tombstone, Arizona, and traveled there to see them in 1883. His large estate in Hampton Bays was located on the west side of the Rampasture Peninsula, and he also owned the Loughrea Farms on Ponquogue Avenue. Following his death in 1909, his widow, Margaret Loughran, continued to summer at Good Ground. In 1933, Henry Loeffler, a builder and another member of Brooklyn society, bought the Loughran House. In 1937, the house was house cut up into two sections, with two of the Loeffler daughters, Mrs. Bodenheimer and Mrs. Jurgens, each being given half to become homes of their own. The project to divide up the house was begun November 7, 1937, and was completed in May 1938. (HBS.)

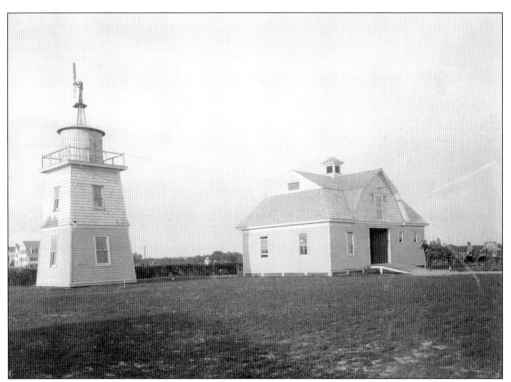

THE LOUGHRAN CARRIAGE HOUSE AND WATER TOWER, C. 1901. When the Loughran estate was divided, the carriage house was moved to the property of Mrs. Jurgens, where it became the garage, while the water tower was permanently disassembled. (HBS.)

CAFFREY HOUSE, 1912. Built around 1907, the Caffrey House was owned by George J. Caffery, a member of the Coast Guard, until 1942. It was then acquired by the Walsh family, and since 1967, John Pizzuti, who operates a number of rental units on the property, owns it. The main house contains a rare example of mural painting done by an itinerant artist. (Author.)

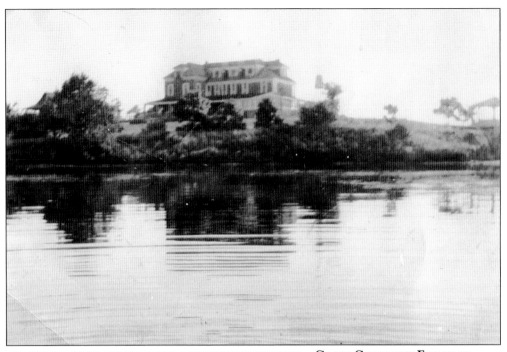

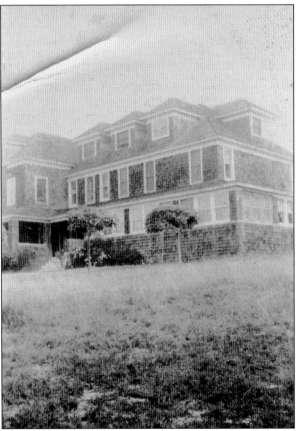

GRACE CREST, THE ESTATE OF WILLIAM C. LESSTER, 1930S. Formerly the Hampton House, the hotel was acquired by William C. Lesster (1907–1975), who had the top floor taken off and renovated the structure into his summer home. The lovely shingled mansion was destroyed by fire around 1945. (Both, HBS.)

Four

HUNTING

Hunting in all its aspects was essential for most rural residents of eastern Long Island—both as a way to supplement their food supply as well as a way to make extra money. It had been fairly restricted during the 19th century as property owners tried to protect their own rights, but hunting was eventually opened up through the efforts of Judge Wauhope Lynn. He was among the first residents in Hampton Bays to open all his properties to unrestricted hunting, posting signs that read, "Free shooting allowed on these grounds—W. Lynn, owner." Geese and ducks would be hunted locally and packed for shipment to New York, where they would grace the tables of fine eateries throughout the city. Market gunners could expect to receive anywhere from $42.75 to $45 per dozen depending on whether mallards, redheads, or canvasback ducks were delivered. In addition, many types of waterfowl were hunted for their feathers, which adorned women's hats. In the end, all these activities depleted the numbers of waterfowl, leading to the end of commercial gunning and the introduction of bag limits for hunters in 1918. Hampton Bays was famous for its hunting guides, who led wealthy visitors on hunting expeditions on Shinnecock Bay, including famous baseball players Babe Ruth and Lou Gehrig. Among the more notable guides and hunters were Eugene A. Jackson (1857–1928), William Lane (1840–1915), Frank Downs Sr. and Jr., Donald Penny, Fred Caffrey, Harold Jackson, Howard Jackson, and L. Wendell Squires (b. 1888).

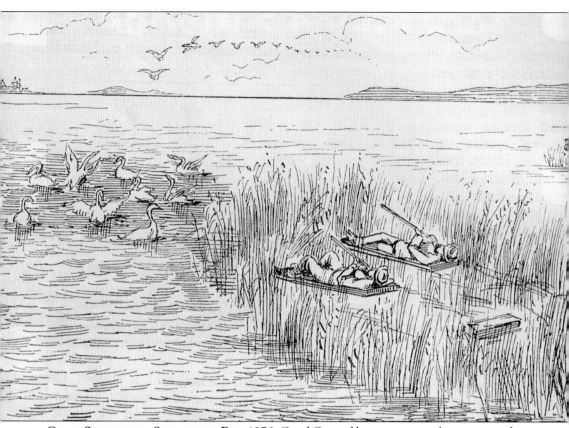

GOOSE SHOOTING IN SHINNECOCK BAY, 1876. Good Ground became a prime hunting spot during the late 19th century, as can be seen by this illustration that appears in a *Scribner's Magazine* from 1876. *Scribner's* notes that "there is capital goose shooting (the best in our vicinity)" in this part of eastern Long Island, which was only a train ride away from New York City. (HBS.)

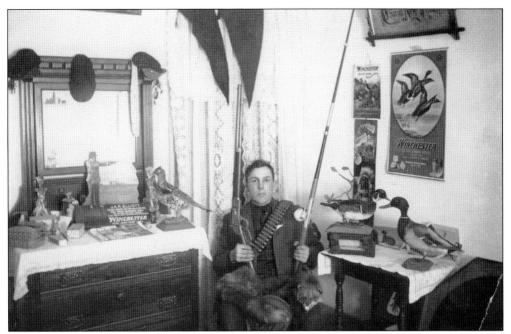

L. Wendell Squires with Trophies on Display, c. 1905. Lawrence Wendell Squires (b. 1888) was among the best noted hunters of the early 20th century to hail from Hampton Bays. A young Squires is shown here with his hunting and fishing equipment as well as with some of the many birds and animals he bagged. (HBS.)

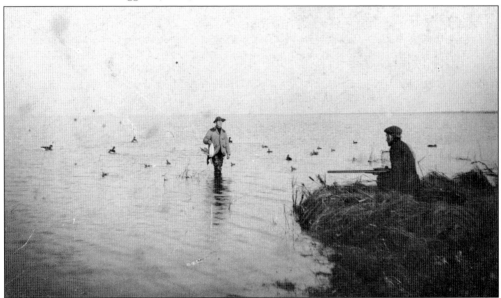

Bringing in a Brant, Lawes Island, Hampton Bays, c. 1908. Wendell Squires makes his way to shore after Noble Chapman bagged a brant out in Shinnecock Bay. Noble (b. 1884) and his brother Will (b. 1878) were residents of Patchogue, Long Island, where they worked as photographers—making the taking of these images quite easy—and came to hunt at Hampton Bays on their Easter vacation. Lawes Island is one of several small wetland islands located between East Point and Ponquogue Point. (HBS.)

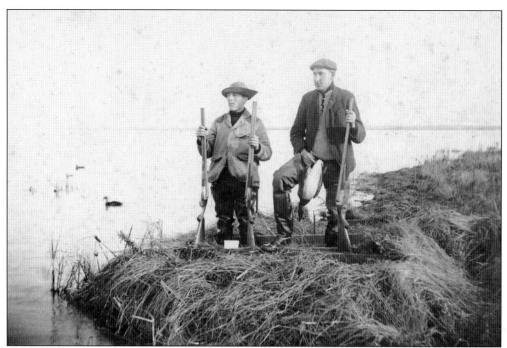

POSED FOR A GREAT DAY, C. 1908. Wendell Squires (left) and Noble Chapman stand ready along Shinnecock Bay with their guns and their first prize of the day, a brant. They stand in what appears to be small blind set up for hunting purposes. (HBS.)

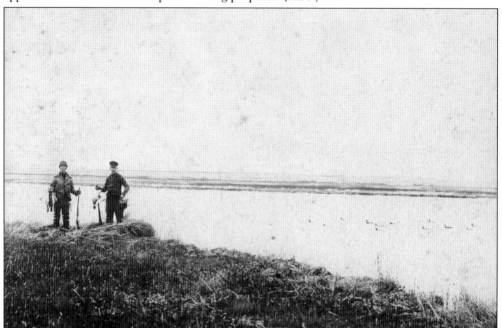

SHELDRAKE HUNTING, C. 1908. Sheldrakes—more commonly known today as shelducks—are a group of larger waterfowl that fall between ducks and geese. This image of Wendell Squires and Will Chapman was taken along Shinnecock Bay at the popular hunting location known as the Hole-in-the-Wall, later known as Warner's Island, just east of the Ponquogue Bridge. (HBS.)

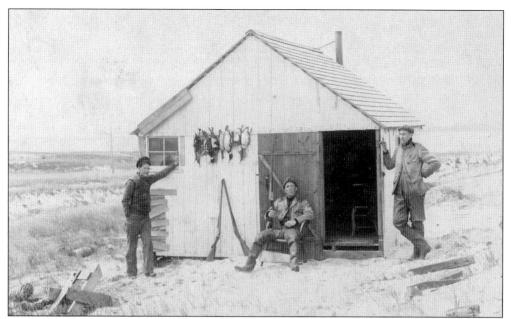

AT THE HOTEL D'HON, C. 1908. This image shows the little shack on the beach known as the Hotel D'Hon, which translates into English as the Hotel of Honor. Posed in front of it are Will Chapman, Wendell Squires, and Noble Chapman. A few of the day's prizes are mounted on the wall of the shack. The cabin occupied by the Chapmans and Squires is a good example of the modest accommodations one would expect to find along the beach. (HBS.)

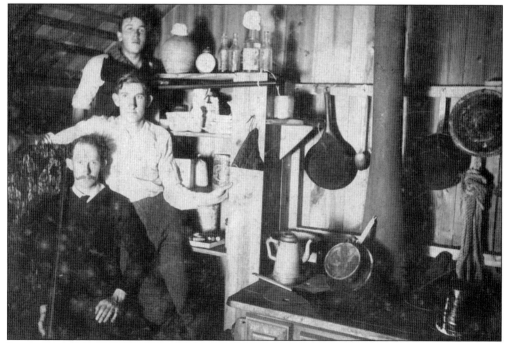

INDIES THE "HOTEL," C. 1908. The interior of the beach shack is shown here with all its accoutrements, including a cooking stove, pots, pans, supplies, and hunting equipment. At left are, from top to bottom, Wendell Squires, Noble Chapman, and Will Chapman. (HBS.)

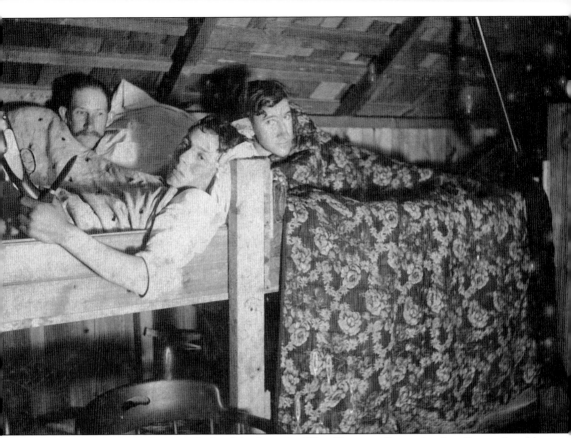

ALL TUCKED IN, C. 1908. The bunk beds in the "Hotel" were sufficient but hardly comfortable. Here, Wendell Squires holds his gun and knife while the Chapman brothers peer out from behind their warm blankets. (HBS.)

READY FOR THE HUNT, 1910s. Hugo Mueller stands at the ready for the hunt, outfitted with waders, a vest capable of holding numerous shotgun shells, his gun, and a binocular case over his right shoulder. Behind him on the porch are drinks, food, and other supplies prepared to keep the men refreshed over the course of their day. (HBS.)

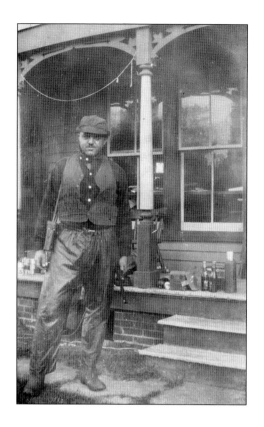

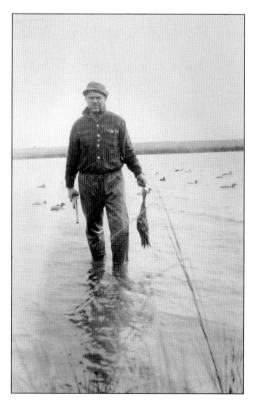

BACK FROM THE HUNT, 1910s. Hugo Mueller is returning to shore with a black duck. Note all the decoys in the water behind him. (HBS.)

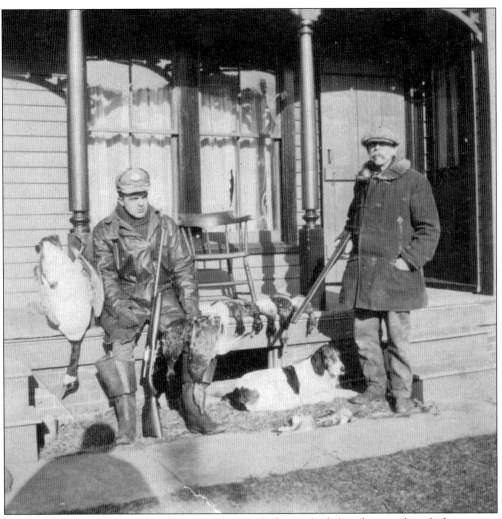

A Successful Day at the Arlington, 1910s. L.G. Squire (right) and an unidentified man pose with a dog and a number of geese and ducks on the grounds of the Arlington. (HBS.)

On Shinnecock Bay, c. 1915. George Mott (b. 1890) of Babylon, Long Island, poses after a successful day's hunting out on the bay with Wendell Squires. Like the Chapman brothers, Mott was also a photographer, working in his hometown of Babylon. In the background, the tower of the Ponquogue Lighthouse can be seen. (HBS.)

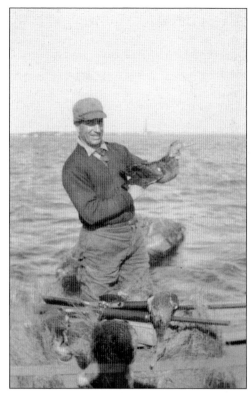

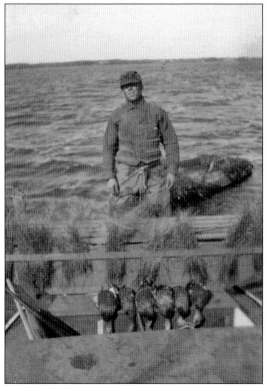

L. Wendell Squires on Shinnecock Bay, c. 1915. Squires stands at the stern of his motorboat while out with George Mott. In the background can be seen his duck scooter. (HBS.)

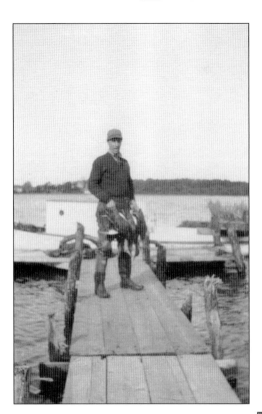

BACK AT THE DOCK, C. 1915. Here, George Mott returns to the dock of Wendell Squires along Shinnecock Bay after a day of hunting. He carries a number of the day's prizes. (HBS.)

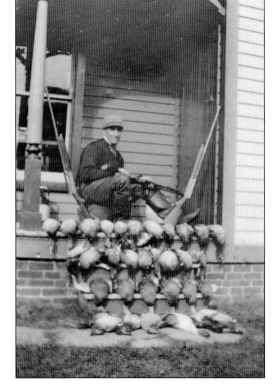

ON THE KITCHEN PORCH, C. 1915. Mott poses on the steps of Wendell Squires's kitchen porch with all the day's prizes— over 30 birds are arranged on display, with Mott and his guns above. (HBS.)

Five

HOMES

Residential architecture in Hampton Bays is not that different from nearly every other small hamlet settled by the 18th century. While most examples were simple in design, like the Barzilla Jackson House (c. 1740), the Ellis Squires House (c. 1790), or the Half Cape–style house built by Prosper King (c. 1830), by the time the railroad came to town things were changing. High Victorian styles became the norm, with homeowners dotting the local landscape with mansard roofs, metal railings, and elaborate porches and brackets. Many local residents updated older homes, while others went brand new. By the early 20th century, large and spacious Shingle Style homes, built both by wealthy summer people and successful local merchants and businessmen, were everywhere, and rightfully so. Servicing the needs of the summer residents helped to transform the lives of the many people who lived full-time in the community, providing the additional income needed to build new, modern homes for themselves. This is still true today.

ELLIS SQUIRES HOUSE, C. 1900. Perhaps the earliest existing house located in Hampton Bays, it was built as the residence of Ellis Squires Sr. (1738–1822). Squires purchased the property in 1785, after hiding during the Revolution "in the swamps and forests" of nearby Red Creek Island. The building, located on Newtown Road, is also known as the Hadley House and was purchased by Southampton Town in 2007. (Both, HBS.)

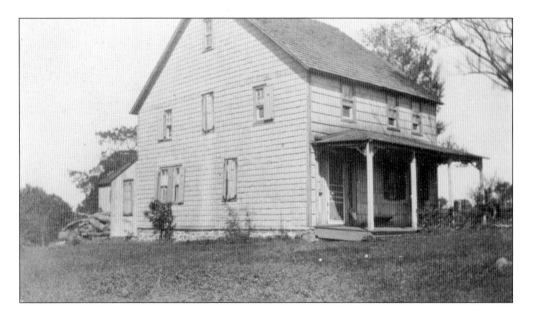

BARZILLA JACKSON HOUSE, 2005. Dating to as early as 1737, the Barzilla Jackson House was located on the west side of Canoe Place Road. It was the home of local postal clerk Walter H. Jackson during much of the 20th century. It remained in the Jackson family until the early 2000s, when it was sold. Its new owner demolished the house in 2009. (HBS.)

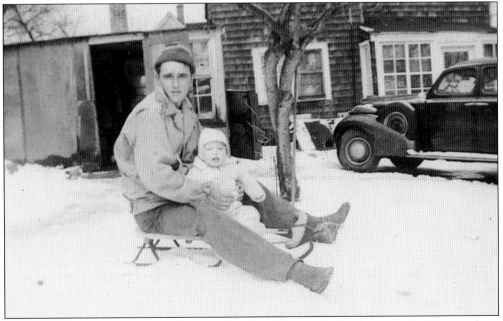

WALTER H. JACKSON (1916–1987) AND HIS SON WALTER R. JACKSON (B. 1943) ON A SLED OUTSIDE THE BARZILLA JACKSON HOUSE, 1945. Walter H. Jackson worked for 52 years at the Hampton Bays Post Office—a record for which he received a special ring from the postmaster general. He eventually retired as the assistant postmaster. (HBS.)

WAKEMAN FOSTER HOUSE, C. 1900. This house was completed in 1813 for Wakeman Foster's son John; he exchanged it with his father's a few years later. Wakeman resided in the house until his death at the age of 91 in 1829. The home left the family after 140 years of ownership when Susie Graham sold it in 1955 to Gordon Jackson of Islip. The house is no longer standing. (HBS.)

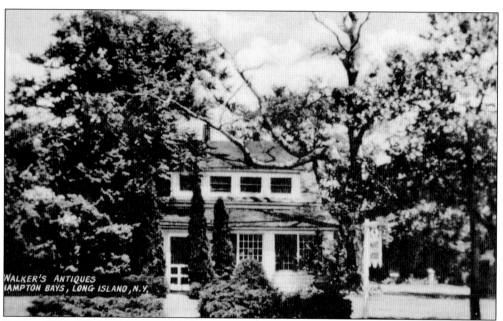

PROSPER KING HOUSE, C. 1951. Built around 1830 for Prosper and Mary King, it was known in the family as the old-fashioned house. William W. Heimburg opened Walker's Antiques there in 1951. Robert Jones Jr. and George Tetzel purchased it in the 1960s and opened Ada's Attic antiques shop, which they ran for 35-plus years. The house was purchased and preserved by Southampton Town in 2005. (HBS.)

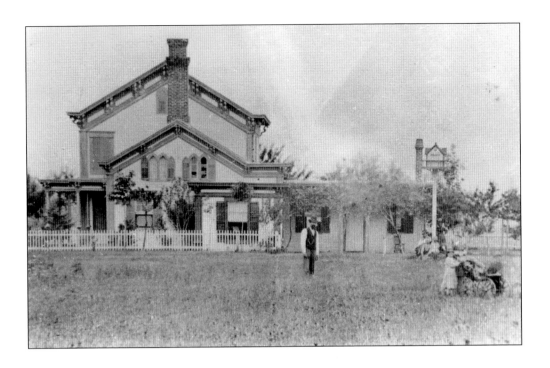

ALLEN P. SQUIRES HOUSE, 1870s. This large home was the residence of Allen P. Squires (1832–1914) and his wife, Rosetta. Squires was involved with the whaling and mercantile trades and was at least part owner of a number of whaling vessels during his lifetime. The house was located on Main Street, just west of Squires's store, and was later home to the Hampton Bays Post Office. Later, the site of the house was occupied by the Leander Squires, Greenburgs, and Thompson's grocery stores. (Both, HBS.)

5648 RESIDENCE OF THE POSTMASTER, GOOD GROUND. L. I. ILLUSTRATED POST CARD CO., N. Y.

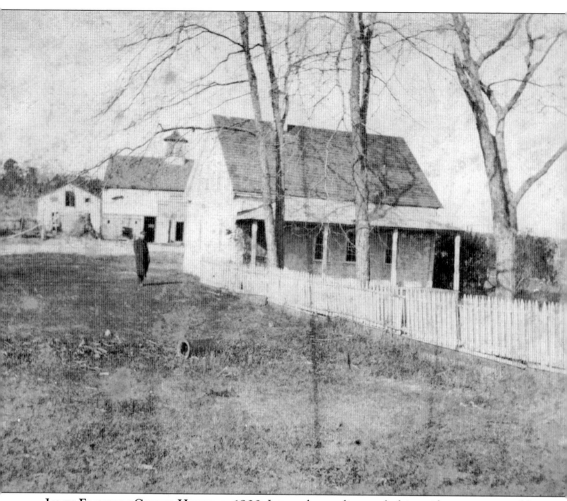

James Franklin Carter House, c. 1900. Located near the canal, this residence was owned by James Carter (b. 1854), a carpenter by trade. A great tragedy unfolded for the Carter family at their home when, in December 1903, son Harry (b. 1884) was critically wounded when his little brother John (b. 1897) managed to pulled the trigger of his rifle, which was resting up against his chest. (HBS.)

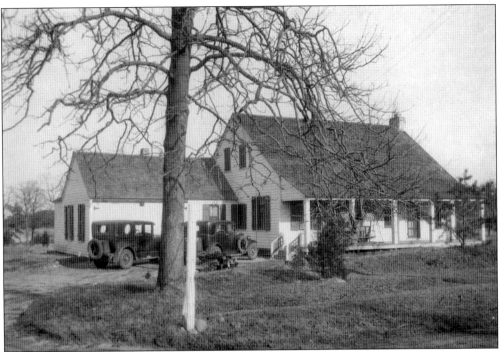

GLEASON HOUSE IN RED CREEK, C. 1925. The Gleason House is located along the west side of Squiretown Road, between Newtown Road and Squires Pond Road. An early home of the Squires family, its was owned by an "Eng Squires" in 1916. (HBS.)

THE HOLZMANN HOUSE, 1930s. Christian F. Holzman came to Hampton Bays from Syracuse in 1890 to work on the Shinnecock Canal. Here, he met and married Clarissa Edith Hubbard. Her father gave the couple a large number of acres along the Shinnecock Canal, where they began to raise fruits and berries. The house remains in the family to this day. (HBS.)

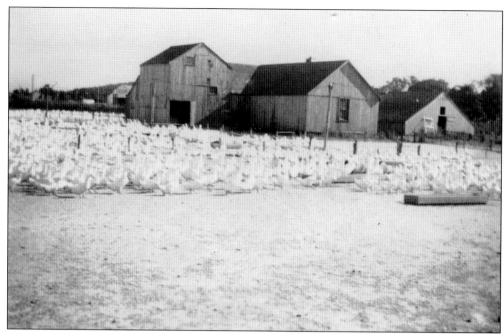

ON THE HOLZMAN FARM, 1910s–1920s. By 1908, Christian Holzman began to raise all sorts of poultry, including chickens and eventually ducks, a decision that led to great prosperity for his family. Here, ducks gather near some of the farm buildings n the Holzman farm. (HBS.)

FANNING HOUSE, 1900s. Located on Ponquogue Avenue, the Fanning house's claim to fame is that it was home to the first telephone switchboard in Hampton Bays. The switchboard was moved on January 15, 1920, to a nearby building owned by Alvin Squires, ending the Fanning family's telephony business. (HBS.)

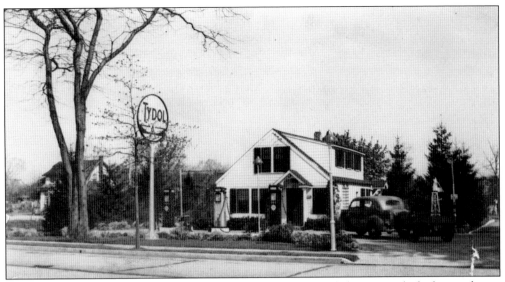

HORNETT HOUSE, 1940s. Formerly the farm of George E. Aldrich (1860–1919), the house, dating to about 1800, and land later became home to the gas station of Dan Hornett. During Hornett's ownership, he operated a Tydol station, and after the brand's retirement, he supplied Mobil and won awards for "the station's attractive appearance." Empty for many years, the house was demolished in 2001 by the Hampton Bays Fire Department. (HBS.)

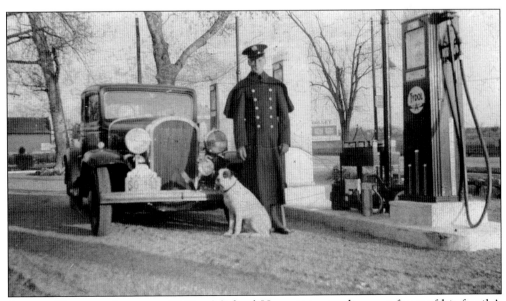

AT THE HORNETT STATION, 1940s. Michael Hornett is standing out front of his family's station. Hornett (1922–1944) would become one of Hampton Bays' casualties during World War II. (HBS.)

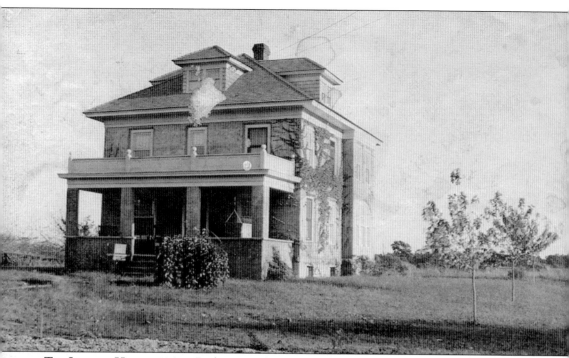

THE JACKSON HOUSE, 1940s. Built in 1912 by and for local resident Elmer Jackson, this stuccoed house was a prominent sight as one entered Hampton Bays from the west and was located on the south side of Montauk Highway. As is the case across all of Long Island, there is a growing interest in removing older homes and erecting new, commercial structures on what were once residential lots. In the early 2000s, the Jackson House was threatened by development, and many local residents were opposed to its possible demolition. (HBS.)

THE JACKSON HOUSE RUINS, 2004. Though many local people wanted to see the house saved when it was threatened with demolition around 2003, it was eventually demolished in 2004. A Friendly's restaurant now occupies the site. (HBS.)

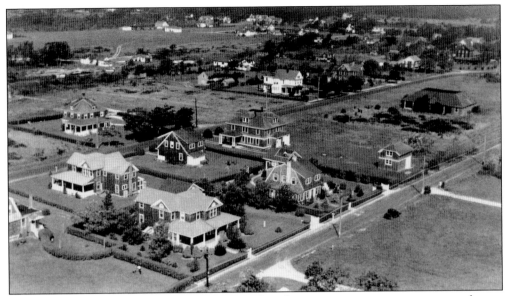

AERIAL OF NEW HOUSES, 1920s. As Hampton Bays became more prosperous, more and more people moved to the community, building their own year-round as well as summer residences. This photograph, taken from the tower of the Ponquogue Lighthouse, depicts some of the newer homes—many of which were built for the Penny family. In the upper right is the old Shinnecock Field Club not long before it would be acquired for the new American Legion post. (HBS.)

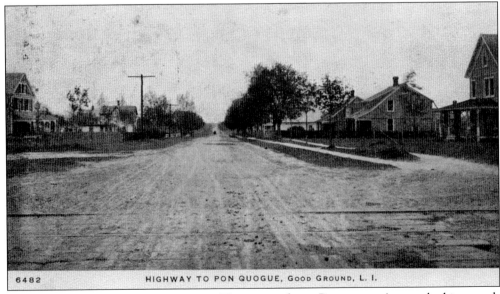

6482 HIGHWAY TO PON QUOGUE, Good Ground, L. I.

THE HIGHWAY TO PONQUOGUE, 1910s. This image shows Ponquogue Avenue looking south toward the beaches. Many of the late Victorian homes depicted here still stand along Ponquogue Avenue to this day. (HBS.)

Six

RECREATION

Like in most communities on Long Island during the early period, religion would have dominated any free time that residents had. Most churches were located quite distant from the homes of many residents, and services could occupy a full day or more in some cases. But it was during the resort period when all the hotels and boardinghouse established new ideas of what recreation could be. Bathing and sailing became immensely popular, with local hostelries offering boat rides to the shore beaches. Bicycling became important during the late 19th century, so much so that an article from the period notes that Good Ground was full of them. Gaming and other sports were supported and promoted through the activities of the Shinnecock Field Club and the casino, which became a favorite spot for the South Fork summer crowd to play. Groups from the western part of Long Island began coming out to establish private retreats, such as the Hampton Pines Club and Camp Tekakwitha, to house their summer populations.

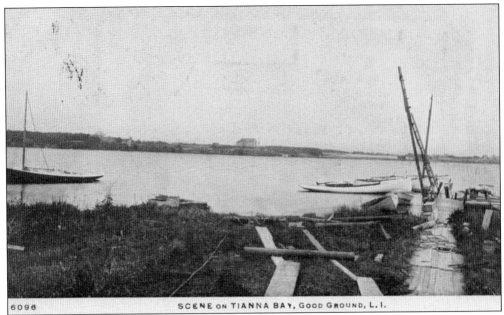

SCENE ON TIANNA BAY, GOOD GROUND, L. I.

SCENE OF TIANA BAY, 1910s. The westernmost bay in Hampton Bays, Tiana was a very popular summer resort and sailing area during the late 19th and early 20th centuries. It was also popular in winter for ice-skating, and in 1888, a young man fell there while maneuvering on the ice and accidentally set off a live gun cartridge in his pocket, badly tearing and burning his clothes. He was lucky and survived. (HBS.)

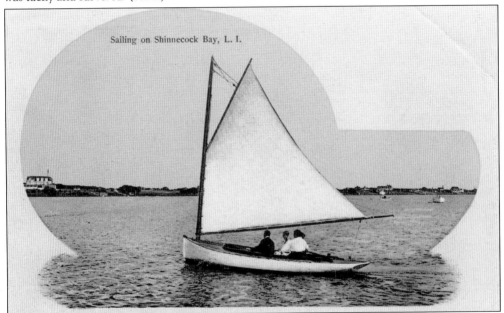

Sailing on Shinnecock Bay, L. I.

SAILING ON SHINNECOCK BAY, 1900s. Though this is supposed to be Shinnecock Bay, this is actually a view looking east on Tiana Bay. Postcards such as this one, depicting the beauty of Hampton Bays, promoted the village as a vacation spot to all who received them through the mail or took them as souvenirs. The large structure in the far left background is the Lesster estate, Grace Crest. (HBS.)

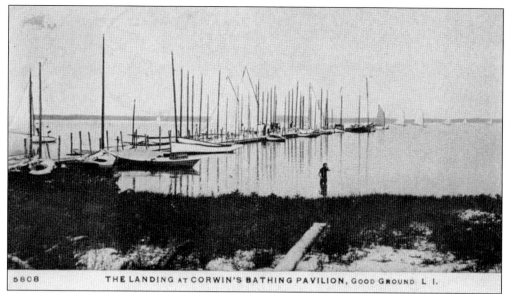

5808 THE LANDING at CORWIN'S BATHING PAVILION, Good Ground L I.

LANDING AT CORWIN'S PAVILION, 1900s. William Howard Corwin's pavilion was located along the shores of Tiana Bay, where he controlled one of two bathing beaches in the late 19th and early 20th centuries. It, along with the one operated by his competitor, Whiteman Terrell, was a popular site for vacationers. (HBS.)

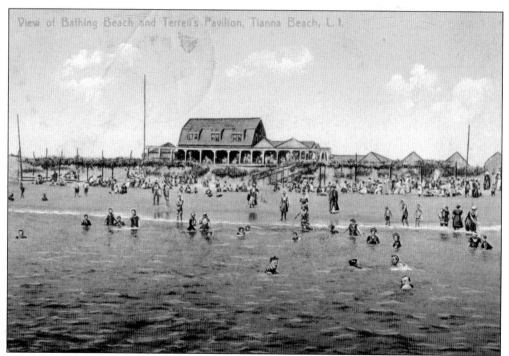

TERRELL'S PAVILION, 1900s. Whitman Terrell was the owner of the other bathing beaches at Tiana, and also like Corwin, Terrell offered snack counters, dance floors, bathhouses, and covered arbors for protection from the sun. Both beaches declined in popularity with the advent of the automobile and were partially destroyed by the Hurricane of 1938. (HBS.)

STARTING THE DAILY TRIP TO THE BATHING BEACH, 1900s. Each day, the many boardinghouses and hotels operated vessels to take their customers over to the beaches, as there were no bridges. Following the completion of the Ponquogue Bridge, this was no longer required. Here, a group prepares to make the short journey. (HBS.)

SMALL BOATS PREPARING TO HEAD OUT ON SMITH CREEK, 1910s. A group of vacationers poses before small sailing vessels, prepared to set out for a few hours on Shinnecock Bay. In the right background, the tower and mansion of the Gilsey estate can be seen. (HBS.)

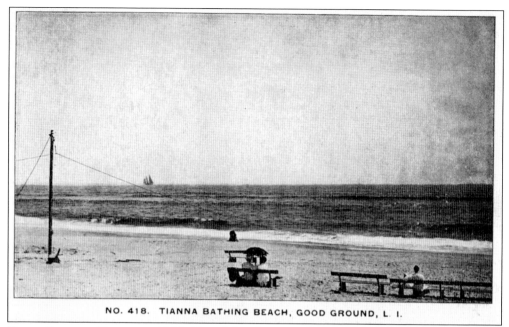

NO. 418. TIANNA BATHING BEACH, GOOD GROUND, L. I.

TIANA BATHING BEACH, C. 1900. Tiana's beaches remained popular until the coming of the automobile. Without boats making their way to the beach, it fell out of favor, especially after the Ponquogue Bridge made access to the present town beach easier. (HBS.)

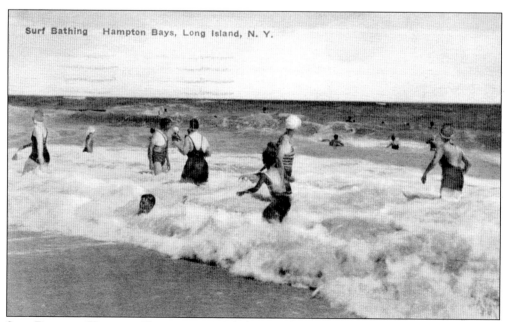

Surf Bathing Hampton Bays, Long Island, N. Y.

SURF BATHING, HAMPTON BAYS, 1930s. With the completion of the bridge to the barrier beach in 1930, the practice of taking people to the shore by sail or motorboat came to an end. Now, everyone could easily get to the sprawling beaches along the south shore of Hampton Bays. (HBS.)

THE BEACH AT GOOD GROUND, C. 1950. The beach has always played an important role in the history of the village. From the gathering of shellfish to the sports and commercial fishing industries, the beach has been a constant. Since the late 19th century, its primary purpose has been recreational, providing weary city folk with a breathtaking respite from the often dreary and dirty city. (HBS.)

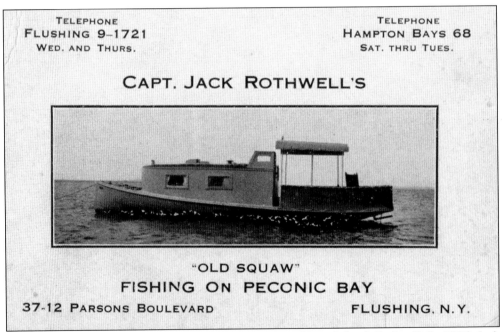

JACK ROTHWELL'S CARD, 1930s. The son of prominent doctor John J. Rothwell (b. 1872), Jack Rothwell (1907–1980) lived in Flushing, Queens, and was an engineer by trade. During part of the week, usually Saturday through Tuesday, he provided his fishing charter services in Hampton Bays. His vessel, the *Old Squaw*, is pictured here on his business card. (Author.)

JOHANSSON FAMILY FISHING, 1930S.
Fishing was not just a profession in
Hampton Bays but also a recreational
activity that brought all manner of people
and ages together. Here, members of the
Fred Johansson family, both young and
old, enjoy a day of fishing. (HBS.)

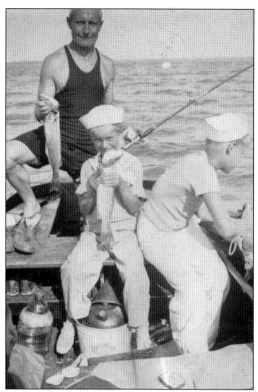

**MAIN STREET WITH THE BAYS THEATRE,
1940S.** Kids growing up in Hampton Bays
during the 1940s made the Bays Theatre
on the north side of Main Street their
second home. For 15¢, patrons got a half
hour of cartoons, the latest *Superman*
installment, plus a full-length film. The
old wooden theater, a mainstay of the
community, was damaged by fire in 1947
and showed its last film in 1953. (HBS.)

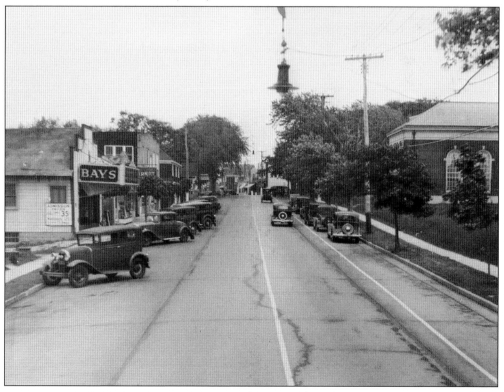

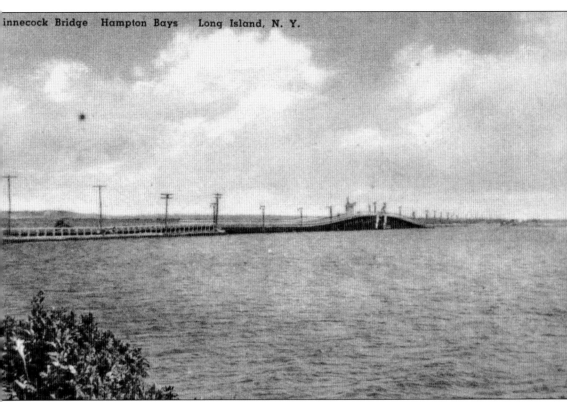

SHINNECOCK OR PONQUOGUE BRIDGE, 1930S. The creation of a bridge to link Ponquogue to the barrier beaches south of Hampton Bays took a step forward in 1925 when the Long Island State Park Commission took an option on 350 acres of shorefront property "to be connected with the mainland by a bridge from the Ponquogue lighthouse." In August 1930, the completed drawbridge was dedicated by sitting governor Franklin D. Roosevelt and former governor Alfred E. Smith. After it was opened to traffic, the new bridge nearly eliminated the boat service once required to get to the barrier island beaches prior to that time. It had a major drawback, however, that when a masted ship wanted to pass through, the open drawbridge would cause traffic to back up for miles. The old bridge was replaced by the present, taller structure, which did not need to open, in 1986. (HBS.)

SHINNECOCK FIELD CLUB, 1900S. The Shinnecock Field Club was in existence before 1913 when it held a Labor Day dance. In 1917, the club, located on four acres along Montauk Highway, replaced its old building with a brand new clubhouse, which was noted as being "modern in every particular." On June 17, 1917, the officers of the club held a formal opening and dance to mark its completion. The club was in existence through at least 1921, and later, the building became the home to the American Legion. (HBS.)

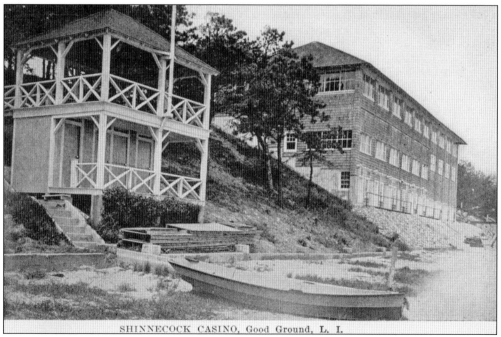

SHINNECOCK CASINO, Good Ground, L. I.

SHINNECOCK CASINO, 1910S. Constructed around 1911, the casino was considered one of the finest clubs on eastern Long Island. Sumptuously furnished, the club was located on a high bluff near Lynn Avenue with superb views. The club was partially destroyed by a fire that started in the basement electric plant of the structure on Monday, July 12, 1926. Purportedly raided by Prohibition agents several times and burned several times in response, the building was finally lost in its entirety in 1928. A regional newspaper notes, "It was a favorite rendezvous of the wealthy summer residents of the Hamptons." (GT.)

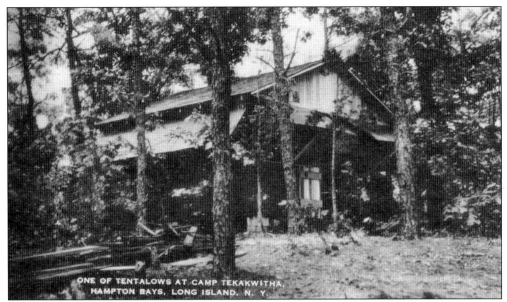

ONE OF THE TENTALOWS AT CAMP TEKAKWITHA, 1940s. This popular Girl Scout camp began as the Hampton Pines Club, which was founded in 1900 and had a hotel on-site by 1904. Located along Red Creek Road, it included both dormitories and cabins and was established for the "exercise of social intercourse, gymnastic, aquatic, field, and general outdoor sports." The club served as the home of the Hampton Pines Art Colony, which briefly succeeded William Merritt Chases's Shinnecock School of Drawing and Painting, in 1903. In 1916, it served as the housing location for children affected by the polio epidemic. (HBS.)

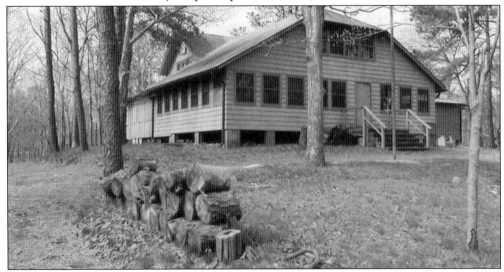

CAMP TEKAKWITHA, C. 1999. Around 1938, the Diocese of Rockville Centre in association with the Southern Nassau County Girl Scout Councils acquired the former Hampton Pine Club property to use as a camp. The camp name, Tekakwitha, was selected to honor Kateri (Catherine) Tekakwitha (1656–1680), the first Native American woman to be canonized by the Roman Catholic Church. In 2007, the Town of Southampton's Community Preservation Fund acquired the camp, and today, it is open to the public as Squiretown Park. A number of the original buildings survive. (HBS.)

Seven

THE CANAL, INLET, AND LIGHTHOUSE

In the days when the Shinnecock Indians dominated the South Fork, the area where the canal now lies was "the place commonly knowne where the Indians hayle over their canoes from the North Bay to the south side of the island." The ability to easily access both Peconic and Shinnecock Bays was an issue that, by the late 19th century, could only be resolved by the construction of a canal. Begun in 1884 and completed in its first iteration in 1892, the Shinnecock Canal allowed the greater movement of ship traffic and aided in the improvement of the shellfish industry. Improvements were made in 1896, 1919, 1930, and 1968 when updated gates and locks were installed. Today, the canal serves as an important commercial waterway for both business traffic and pleasure craft alike. Though storms had opened the Shinnecock Bay to the sea forming an inlet many times, by the late 19th century, it had happened so rarely that the loss of salinity was endangering the shellfish and finfish that lived in the bay. In 1895, it was dug open by hand. Later efforts to open the inlet were partially funded by Judge Lynn and other wealthy summer residents. The problem was permanently solved when the Hurricane of 1938 cut a huge opening in the barrier beach, which led to the stone-reinforced opening seen today. The now lost Ponquogue Lighthouse was an important beacon for ships traveling along the treacherous south coast of Long Island. Its destruction during the 1940s—as was the fate of others of its kind—gives residents pause to this day.

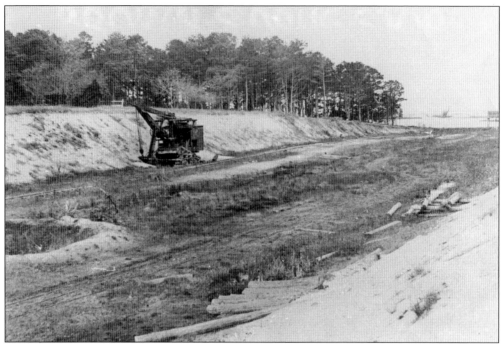

THE CANAL BEING DUG, 1880s. An early steam shovel sits ready to make headway. The canal was built between 1884 and 1892, and work started and stopped, as can be seen by all the grass growing in the bed of the canal during a slow period. (HBS.)

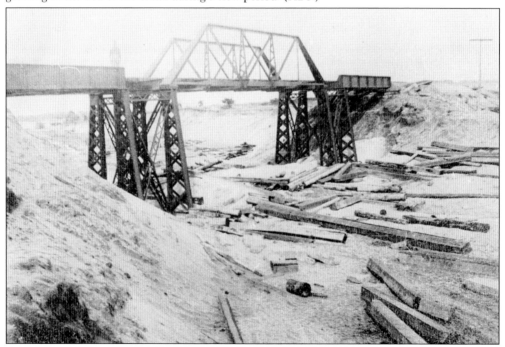

THE RAILROAD BRIDGE BEING BUILT, C. 1887. The bridge was built while the canal was under construction and was soon found to be so unsafe and impractical that by 1899 the Long Island Railroad replaced it with a new span. (HBS.)

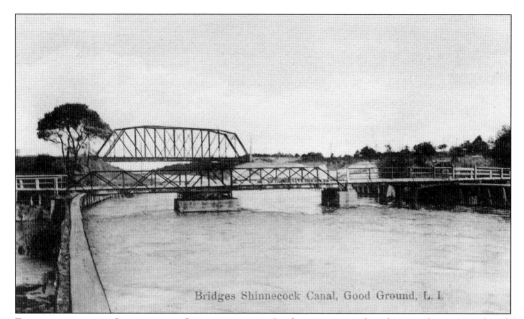

Bridges Shinnecock Canal, Good Ground, L. I.

BRIDGES OVER THE SHINNECOCK CANAL, C. 1900. In the years just after the canal was completed, the land around it remained sparsely inhabited. The addition of bridges designed to carry both trains and wagons/automobiles helped transform the area. The view in this photograph looks north and shows the second railroad bridge (background), completed in 1899, and the old one-lane swing bridge (foreground), which was installed in 1892. (HBS.)

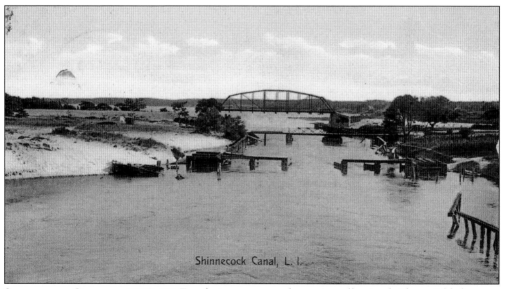

Shinnecock Canal, L. I.

SHINNECOCK CANAL, C. 1907–08. For obvious reasons, the very small swing bridge quickly became more a problem than a solution for wagon and boat traffic, and so it was replaced in 1908 with a new, two-lane span. In this image, the view is looking south from the railroad bridge at the new automobile bridge under construction. (HBS.)

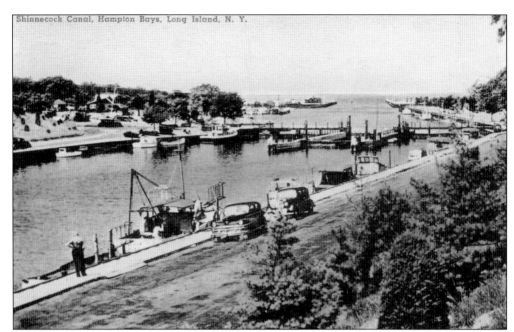

Shinnecock Canal, Hampton Bays, Long Island, N. Y.

SHINNECOCK CANAL, 1930S. The canal eventually became a bustling location for industries related to recreation, especially boating and fishing. Here, many pleasure craft are shown docked along the canals sides, while in the foreground is a fully equipped sport fishing boat preparing for a day's action. (HBS.)

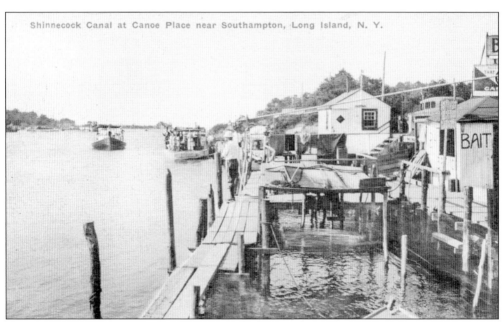

Shinnecock Canal at Canoe Place near Southampton, Long Island, N. Y.

BAIT

SHINNECOCK CANAL AT CANOE PLACE, 1930S. In addition to filling stations and restaurants, other important businesses dotted the shore of the canal, including bait shops. (HBS.)

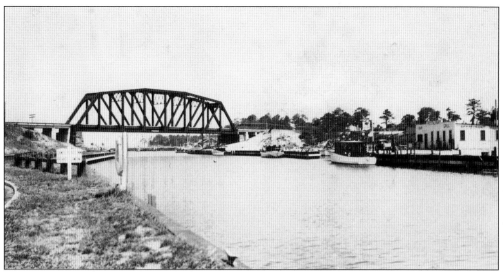

VIEW OF THE CANAL, LOOKING NORTH, 1930S. The 1931 railroad bridge is shown not long after it was erected. The new 800-ton bridge was necessary because the old 215-ton bridge could no longer withstand the growing weight of the much heavier engines and trains that were coming into service. The restaurant at right was later converted into a bait and tackle shop by the Altenkirch family. (HBS.)

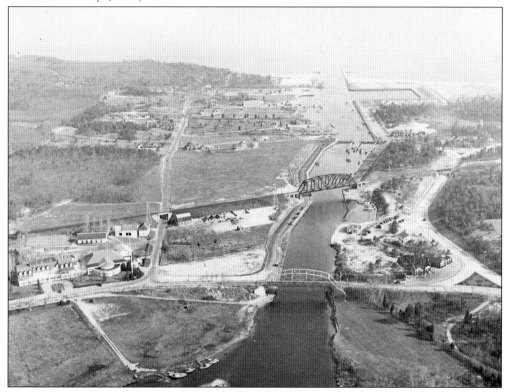

AERIAL OF THE CANAL, 1930S. The northerly railroad bridge and southerly highway bridge are shown looming over the canal. Few houses dot the landscape around the canal. Note the boat landing in the left foreground for the Canoe Place Inn. (HBS.)

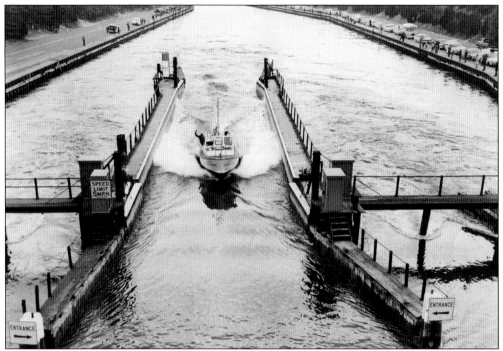

THE OLD LOCK, 1960s. By the mid-1960s, the old 1919 wooden locks and tide gates shown here were showing their age. The Suffolk County Department of Public Works decided to replace them, erecting ones made of steel and concrete in their place. (HBS.)

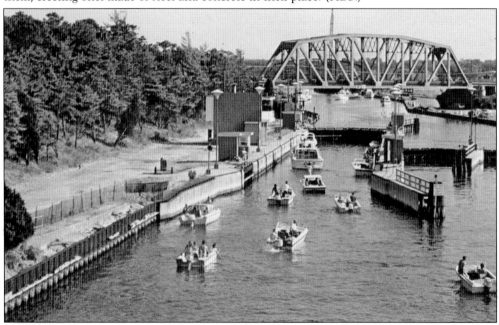

THE NEW LOCK, C. 1970. Work began in 1966, and the new locks and gates were completed in 1968. The Horn Construction Company of Merrick, Long Island, built the new locks for approximately $2.4 million. Here, boaters heading south through the canal make use of the new lock system. (HBS.)

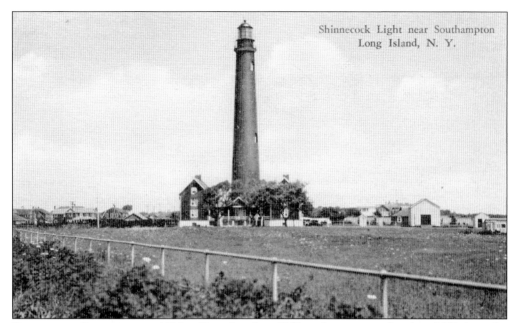

Shinnecock Light near Southampton
Long Island, N. Y.

PONQUOGUE LIGHTHOUSE, 1930S. Completed in 1858 and rising to a height of 170 feet, the Ponquogue Lighthouse, also known as the Great West Bay Lighthouse, was perhaps the most distinctive monument ever erected in Hampton Bays. It was the only beacon located between Montauk Point and the Fire Island Lighthouse, making it an important addition for the protection of south shore shipping lanes. (HBS.)

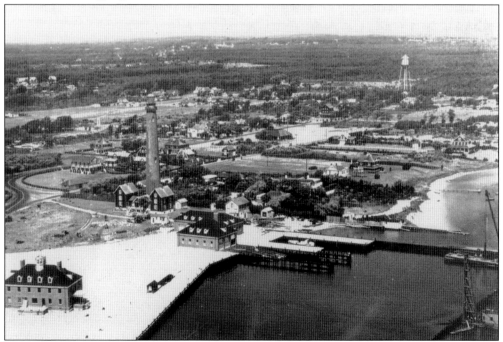

AERIAL VIEW LOOKING NORTH, C. 1940. The lighthouse is shown against the many homes that began springing up during the 1920s and 1930s. In the left foreground is the new Coast Guard station under construction. (HBS.)

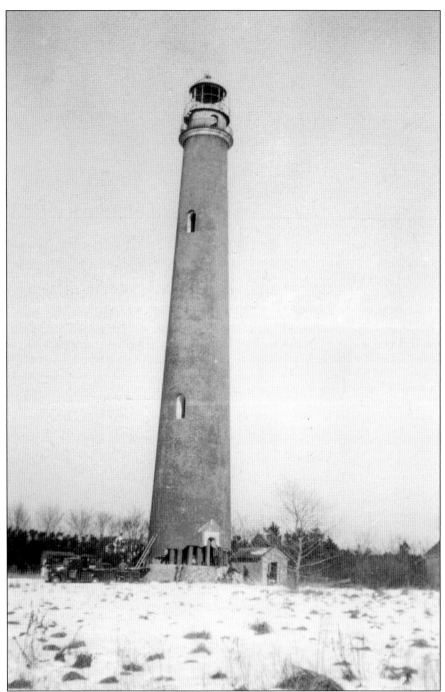

PONQUOGUE LIGHTHOUSE, DEMOLITION, 1948. Taken out of service in 1931, many attempts were made to find a new use for the structure. They all ended unsuccessfully, and in 1947, the Coast Guard requested bids for its demolition, to take place in 1948. The task was eventually awarded to the Vim Demolition and Savage Company. The old keeper's quarters were the first thing to be removed along with salvageable fittings—including the tower windows—to make way for the demolition. (HBS.)

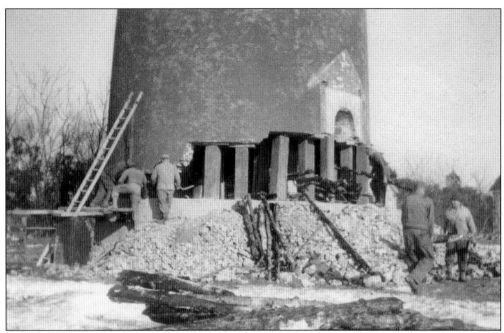

CRIBBING INSTALLED. In early December 1948, crews began the demolition process of the tower by knocking out the bricks at one side of the base while installing wooden cribbing as they moved along, the process took two weeks. When they were ready, the wooden cribbing was soaked with accelerant and was set on fire. As it burned, the cribbing would become weaker and weaker until the tower gave way. (HBS.)

RUBBLE, DECEMBER 23, 1948. The tower of the lighthouse actually fell fairly intact, breaking into a few huge sections as it came toward the ground. However, when it was all over, there was little left resembling the once grand tower except chunks of weathered brick. That day, "there were tears in the eyes of many old timers who stood watching the old landmark pass away, powerless to save the old building." (HBS.)

THE NEW INLET, 1938. This image was taken with the photographer looking east across the newly created inlet. Note the downed and leaning power poles in the far background. Shown standing in the foreground at right looking back at the photographer is Arthur Sinclair, the superintendent of the Hampton Bays Water District. The efforts of local and regional governments led to the installation of wooden pilings in 1939 to stabilize the new inlet, followed by stone jetties in 1952, which were again repaired in 1982. (HBS.)

Eight

ARTISTS COLONY

Beginning in the late 19th century, Hampton Bays and the South Fork of Long Island was discovered by a number of important American artists, among them William Merritt Chase (1849–1916), who was a frequent visitor to the hamlet. Among others who had a connection to the locale was the artist George Bellows (1882–1925), whose father—also named George—was born in Hampton Bays. Russian Modernist David Burliuk arrived in 1940 and opened a gallery with his wife in town in 1952. The famous artist Harry Gottlieb (1895–1983) acquired a home and studio in Hampton Bays also in 1952 and began offering art classes—he would teach adults while his wife, Sara, offered programs for children. Their home and studio were located on Shinnecock Road near Foster Avenue. Nicolai Cikovsky (1899–1984) and the Soyer brothers—Isaac, Moses, and Raphael—also summered and painted in the hamlet. The sculptor Nat Werner (1908–1991) settled in the Shinnecock Hills, where he maintained a home and studio during the 1950s. Hubert Albrecht, who was born in Switzerland, was a chauffeur before he acquired a gas station on Springville Road in Hampton Bays. Beginning in 1940, his wife, Tyne, operated the Haven Guesthouse on Ponquogue Avenue. Albrecht was a painter, working in oil and aquarelle, though he had never received any formal artistic education. The Koumbaroi, a group of artists of Greek descent including George Constant, Theo Hios, Michael Lekakis, and Louis Trakis, had studios in the Shinnecock Hills and brought Modern and Abstract art to the area beginning in the late 1940s.

WILLIAM MERRITT CHASE, MARY CONTENT, AND ROLAND, SHINNECOCK HILLS, C. 1905. Chase shows his artistic side as he carries an enormous Asian-style umbrella through the Shinnecock Hills. William Merritt Chase's art school, which was based out of Southampton, garnered many of America's best and up-and-coming artists. An article published in 1894 notes that the school was at least initially associated with Hampton Bays: "Mr. William M. Chase's Summer Art School in the Shinnecock Hills, near Good Ground, Long Island, when it was started a few years ago was something of a novelty." Though students at first had to board wherever they could find available rooms, by the 1895 season, Chase had erected a dormitory near his own cottage, which was "proving a great convenience" for his pupils. In 1903, the successor to his school moved to the Hampton Pines Club property along Great Peconic Bay in Hampton Bays. (PAR.)

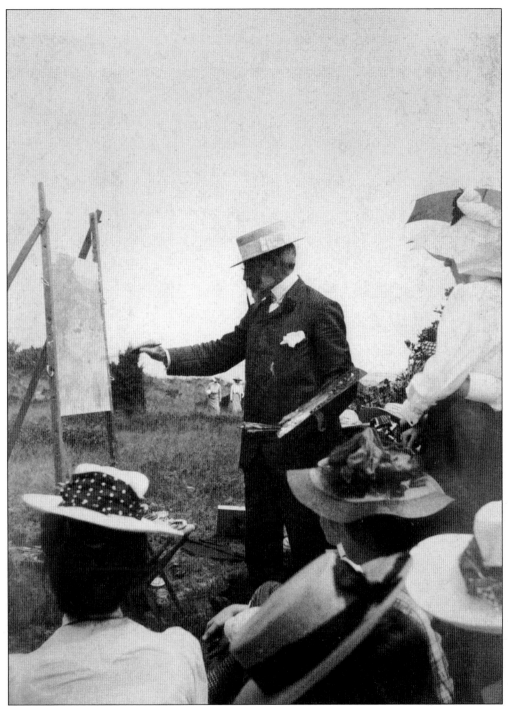

Chase Demonstrating to His Students in the Shinnecock Hills, c. 1900. Chase was a frequent visitor to Hampton Bays, where he painted many scenes that are today wrongly attributed to locations in Southampton. Among those is the painting *Idle Hours*, dated to 1894–1895, which is actually a view of Great Peconic Bay near the entrance to Squires Pond in Hampton Bays. (UHS.)

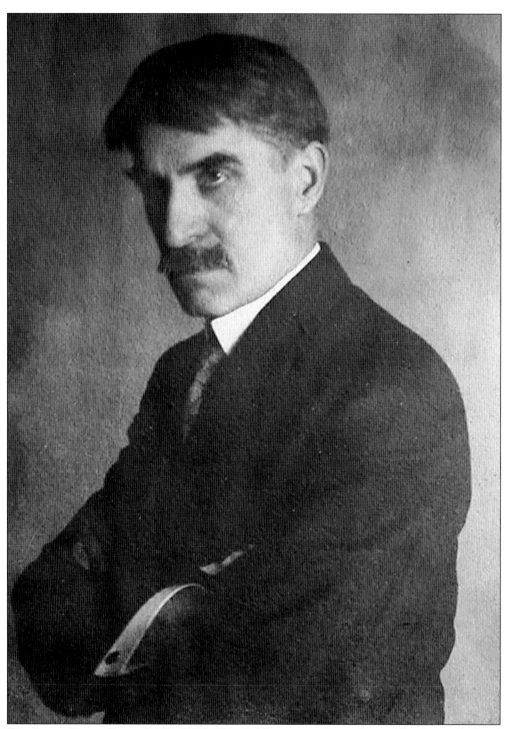

THE ARTIST BRUCE CRANE (1857–1937). Chase's fellow painter Bruce Crane fell in love with Good Ground, which was noted in an article published in 1896: "Good Ground, Long Island, is one of the favorite spots of Mr. Bruce Crane for his annual outing. His studio is ever a popular resort, and even the charms of Milford [Connecticut] . . . fail to lure him for the entire season." (SC.)

KOUMBAROI ARTISTS, THE PARRISH MUSEUM GARDEN, SOUTHAMPTON, 1948. Pictured, from left to right, are George Constant, Nicolai Cikovsky, Nat Werner, Moses Soyer, Alexander Brook, and David Burliuk—all of whom lived in or were associated with Hampton Bays. (KOU.)

GEORGE CONSTANT STUDIO, C. 1949. Constant was forced to give up this studio, located in the Shinnecock Hills near the canal, in 1959 for the creation of the new Sunrise Highway extension. He moved his studio to a Stanford White–designed building on Tuckahoe Lane in Southampton. (KOU.)

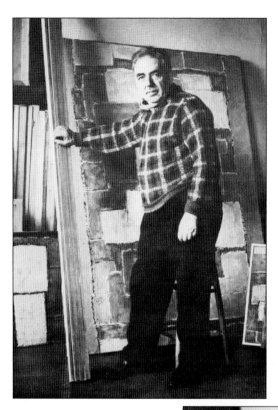

GEORGE CONSTANT IN HIS NEW YORK CITY STUDIO, 1960S. Constant (1892–1978) first visited the Shinnecock Hills in 1945 and quickly became enamored with the place. It was Constant who was the first of a new group of artists that began coming to the Shinnecock Hills in the 1940s. (KOU, S. Waintrab.)

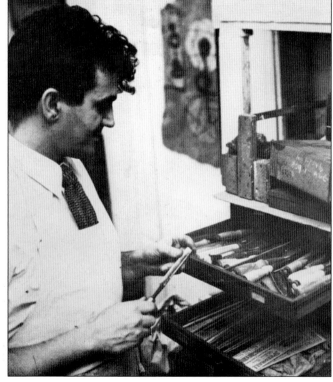

MICHAEL LEKAKIS AT WORK, 1950S. Lekakis (1907–1988) came to the hills in 1960, following his two sisters who were married to George Constant and Theo Hios. Though he started his training in the family florist business, by the early 1940s, Lekakis was leaning toward a career in the art world, and soon, he had one of his first exhibitions of sculpture at the Artists Gallery. (KOU.)

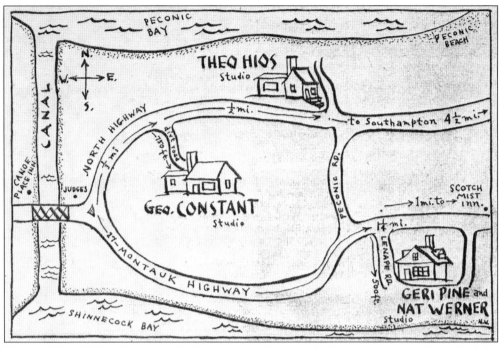

STUDIO MAP, 1954. This map, which was created as a guide for the opening of several of the artists' studios, was published in the August 12, 1954, *Southampton Press*. (GT.)

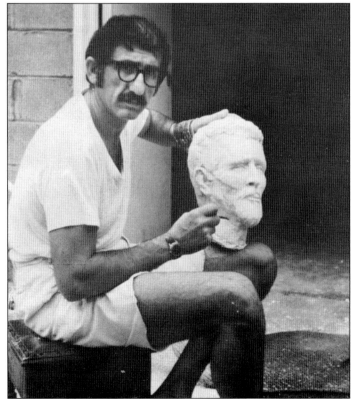

LOUIS TRAKIS, 1968. Trakis (b. 1927) arrived in the Shinnecock Hills in 1955, and though he worked in variety of mediums, he became known for his sculptures. The best man at his wedding, Michael Lekakis, introduced him to many of the other artists who came to work in the Shinnecock Hills. Trakis taught at Manhattanville College from 1965 to 1993 and eventually moved to East Hampton. (KOU.)

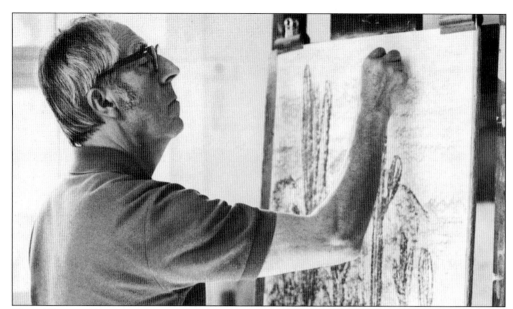

THEO HIOS IN HIS STUDIO, 1979. Born in Greece, Hios (1908–1999) was best known for "his expressive portraits and especially visionary views of nature." His divided his time between New York City and his home and studio in Hampton Bays, located just a short distance east of the Shinnecock Canal. (KOU, B. Drum.)

THE BURLIUK HOUSE, C. 2000. David and Marussia Burliuk Sr. resided in this home beginning in 1942 when it was purchased for them by their son Nicholas. Previously, it had been the home of Fanny and William Smith. The property included studio space for son David Burliuk Jr. in the rear kitchen wing, while Nicholas—who also was an artist—had a studio in the old carriage house on the property. (HBS.)

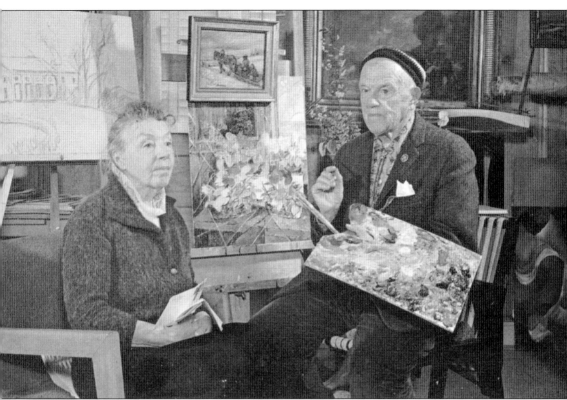

MARUSSIA AND DAVID BURLIUK, C. 1960. The Burliuks pose in the artist's studio in Hampton Bays. The establishment of the Burliuk Gallery by Marussia Burliuk on the corner of Squiretown Road and Old Riverhead Road in 1953 brought Modernism to the small village in a new, public way. Among the artists she exhibited at the gallery during the 1950s were Milton Avery, A. Brook, David Burliuk (her husband), David Burliuk Jr. (her son), Nicholas Burliuk (her son), Biddle J. Brestovan, M. Buckingham, Clyde Singer, M. Becker, Nicolai Cikovsky, George Constant, Gina Knee, Adolf Dehn, Louis Eilshemius, Philip Evergood, Lily Ente, Goncharova, Grigorieff, Gatto, Harry Gottlieb, Charles Gross, Arshile Gorky, Emil Ganso, Marion Geer, Herny Miller, Mina Harkavy, Sascha Kolin, Louise Waller Germann, Dorothy Quick Meyer, Anna Penny, Harry Shulberg, Moses Soyer, Raphael Soyer, Abraham Walkowitz, Sol Wilson, Jouanny Zagoruiko, Ellen de Pazzi, and Myron King. (HBS.)

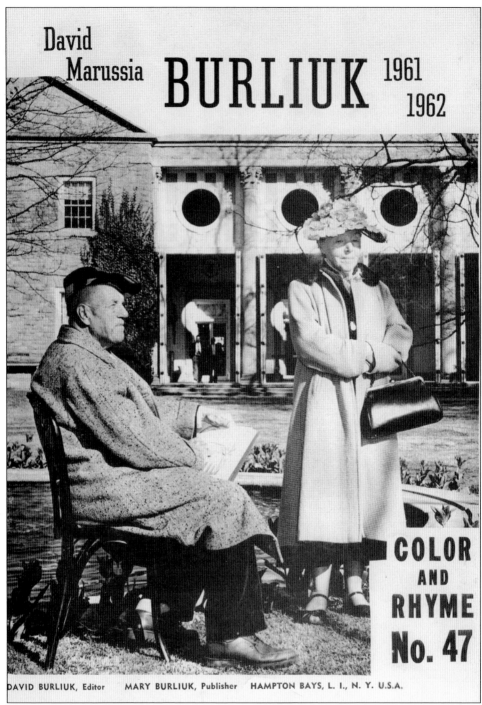

David Marussia **BURLIUK** 1961 1962

COLOR AND RHYME No. 47

DAVID BURLIUK, Editor MARY BURLIUK, Publisher HAMPTON BAYS, L. I., N. Y. U.S.A.

COLOR AND RHYME, 1961–1962. Marussia and David Burliuk published this annual periodical—*Color and Rhyme*, which includes reproductions of his paintings, reviews of recent exhibitions, letters written by him and other notable artists, and some of his original poetry. While interesting, the periodical contains a good deal of incorrect information about Burliuk, even though he was the editor. (HBS.)

Nine

BUSINESSES

It is often the long-term success of local industries that determines the success of any community. The far western United States is a good example of this—it is littered with the remains of places that started out with a boom and ended in a bust. Hampton Bays is no different than many other places, and each business-related success helped the community grow and evolve. Whether it was the offshore whaling industry, fishing and shellfishing, farming, or catering to vacationers, each improved the lives of those who lived in the hamlet. The creation of a local bank during the 1920s allowed the community to grow at an even more rapid pace. As time passed, more and more families created niche businesses that served more and more people in Hampton Bays. The Altenkirchs helped fishermen make the catch, the Jacksons made sure they got everything pressed at their dry cleaners, and the Hornbecks kept everyone's pianos in key despite the humidity. Every business owner who worked hard to serve his clientele made Hampton Bays a better place to live.

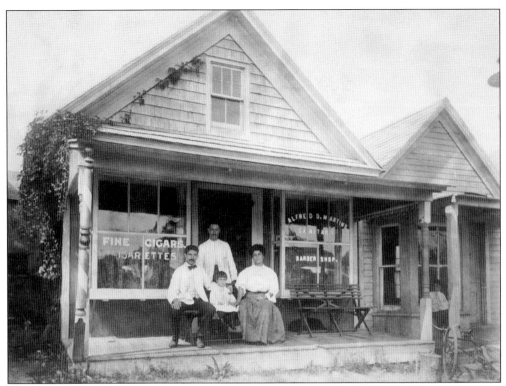

ALFRED D. MARTIN'S BARBERSHOP, C. 1910. Located on the south side of Main Street just east of Ponquogue Avenue, the shop was owned by Alfred Martin, who arrived in America from Italy in 1896. The shop was owned later by Carl Zebrowski, and in 1956, Sal Granatelli purchased it. The barbershop moved to the north side of Main Street, opposite its old location, in 1957. (HBS.)

LYZON HAT SHOP, 1950S. Opened in 1910 by Walter Hewitt King and his wife, the shop was located on the north side of Main Street and became well known for its fine millinery. Clients included the wealthy and notable from around the world, including members of several royal houses in Europe. The shop closed in 1961, and King died in 1968. Today, it is part of preserved property owned by Southampton Town. (HBS.)

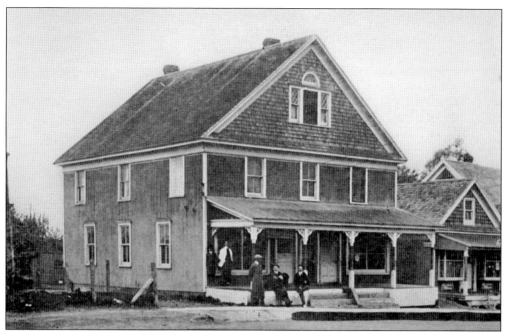

THE POST OFFICE, C. 1910. This building, located just east of Alfred Martin's barbershop (at the far right of the image), was one of nine separate locations that the post office moved to between the late 19th and mid-20th centuries. It only remained here a few years before moving to Leander Squires's building. (HBS.)

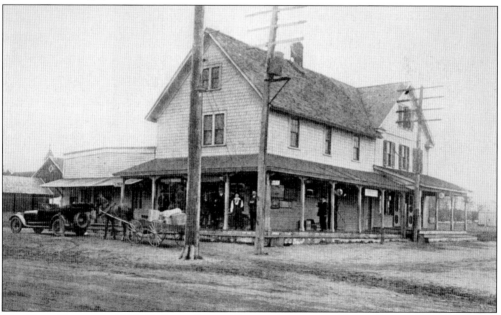

THE POST OFFICE, C. 1916. Fashioned partially out of a converted barn, this prominent business location was first owned by William E. Philips and then by Eckford Jacobs. In 1915, Leander Squires, who expanded the structure further, purchased it. A fire mostly destroyed the building on March 16, 1973. In 1975, the site became home to a Key Foods, whose own building was demolished in 2000. (HBS.)

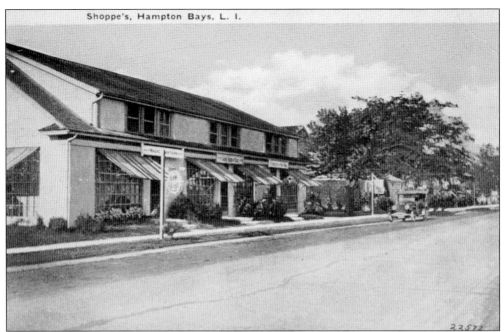

THE SHOPPE'S, 1920s. The Shoppe's was completed in the 1920s on the north side of Main Street, just west of the Lyzon Hat store. The building was known as the Shoppe's during that era when it housed Grande Maison de Blanc (fine linens), Finchley's (a haberdashery), and Ovington's (china and crystal). During the 1930s, the Rainbow Inn was located here. Jane Byrne and Gertrude Stratford operated it, and the inn's food was advertised as being "cooked to tempt your taste." (HBS.)

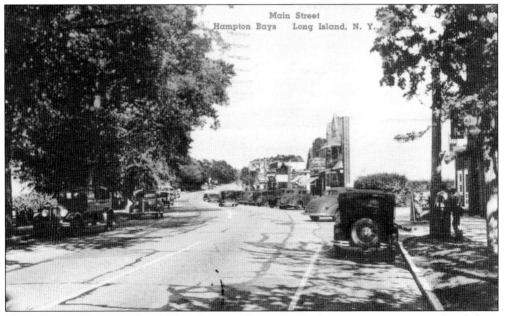

MAIN STREET, HAMPTON BAYS, VIEW LOOKING EAST, 1930s. Large trees are seen overhead along Main Street. Sadly, many of the trees fell during 1938 hurricane. The folding street sign in front of the Chocolate Shop, also known as Spiro's, reads, "Real Home Made Ice Cream." (HBS.)

HAMPTON BAYS NATIONAL BANK, 1970s. As early as 1903, the citizens of Good Ground were discussing creating a bank. However, it was not until June 1926 that the bank was organized, and in 1927, it moved into its own, leased brick building on the south side of Main Street. In 1968, the bank was acquired by Valley National Bank, which was acquired by Bank of New York in 1972. The new Bank of New York Building went up behind the old bank, which was then demolished. The original chandeliers were saved and installed in the Methodist church. (HBS.)

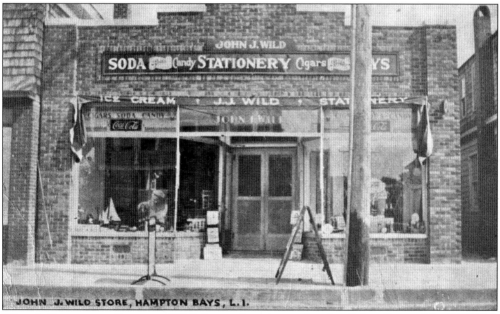

WILDE'S STATIONERY STORE, c. 1930. Located on the south side of Main Street, John J. Wilde's stationery store was originally operated by J.E. Tunnell and was also occupied by Charles Jackson's Rest-a-Bit ice cream parlor. In 1951, James and Carolyn Micari purchased the building from Mr. and Mrs. W.C. Lesster and opened Carolyn's Luncheonette. It was the popular hangout for all the kids in Hampton Bays during the late 1950s. Today, it houses Papa D's restaurant. (HBS.)

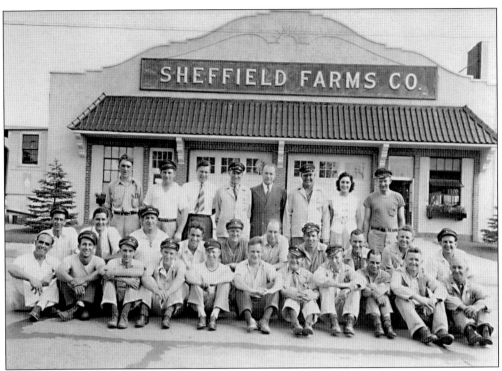

SHEFFIELD FARMS BUILDING, 1930S. First the site of a livery stable, the present building in its spot was originally operated by Adam Mueller, who was a supplier to Kraft Foods. In 1931, the Sheffield Farms Milk Company took it over and used it as its distribution center. Following Sheffield Farms Milk Company's closure in 1939, the building was used as an auto repair shop and garage. Seatronics occupied the building until recently. (HBS.)

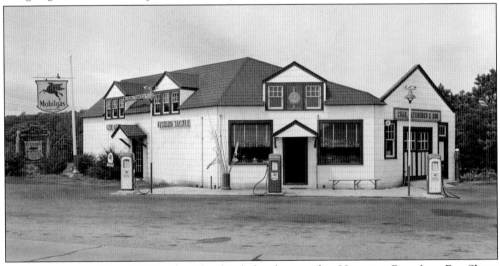

ALTENKIRCH AND SON, 1940S. The Altenkirch family moved to Hampton Bays from Bay Shore and, in 1929, opened up a gas station and auto repair shop on the canal. People kept coming and asking for fishing equipment, prompting them to carry some items in stock. The business became so successful that eventually the family moved into the fishing supply business full-time. The rather worn sign at the left of the image reads, "Fishing Information Cheerfully Given." (HBS.)

ALTENKIRCH AND SON, INTERIOR, 1940s. Well positioned along the Shinnecock Canal, Altenkirch and Son supplied the very finest in fishing gear to the many sport fishermen who came to Hampton Bays. It was operated by Charles F. Altenkirch (d. 1952) and his son, Henry, and later by his grandsons. Miriam Altenkirch, Henry's sister, was in charge of manufacturing the high-quality fishing poles the shop carried. During the 1950s, the firm was getting as much as $1,000 per rod for its top-of-the-line deep-sea models. (HBS.)

HORNBECK & SON PIANO STUDIO, 1930s. Henry S. Hornbeck came to Hampton Bays from the firm of Steinway & Sons. In 1925, he set up a store on the north side of Main Street that furnished pianos to the best homes located on the North and South Forks of Long Island. His son, Harold, continued the business through the 1960s. Inevitably destined for success, the famous composer and conductor Walter Damrosch (1862–1950) said of him, "I have seldom found a man of such worth." (HBS.)

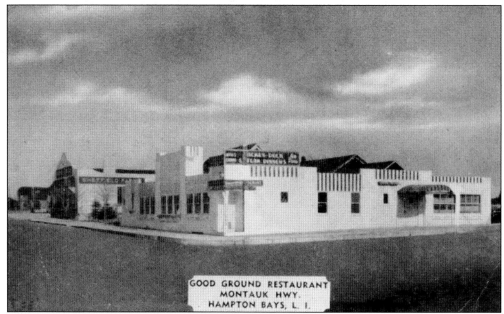

GOOD GROUND RESTAURANT, 1930s. Once located on the corner of Ponquogue Avenue and Main Street, this restaurant started life as the Roosevelt Grill during the 1930s. The owner, a Mr. Economopolus, decided to enlarge and expand his business into what became the Good Ground Restaurant. Higher prices soon doomed the business, and it was closed by the 1940s. The building no longer stands. (HBS.)

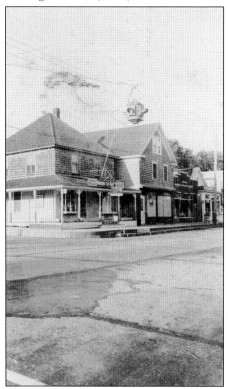

BALZARINE'S RESTAURANT, 1930s. Located on the southwest corner of Ponquogue Avenue and Main Street, this location was originally the site of an early burial ground. After the Methodist church cemetery was opened up, the burials were removed, and the site was occupied by Meschutts's Grocery Store. It was followed by Joseph Balzarine's restaurant, which was known affectionately as Joe's, and finally by Balter's Photography studio. In 1936, the building was demolished, and the land was renamed Ponquogue Park, which later housed the World War II Honor Roll Memorial. (HBS.)

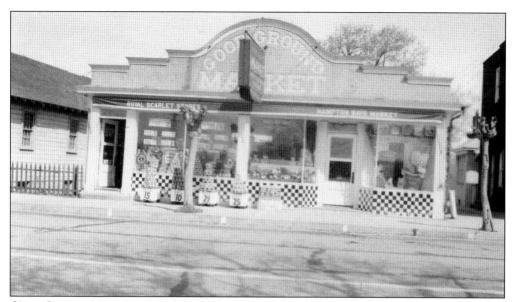

GOOD GROUND MARKET, 1940S. Built by Alwin Scholz, it first housed his butcher shop that was later converted to a full-service grocery store by Theodore Scholz in 1931. The grocery closed its doors for good in 1961. The building, with altered text (the word "Market" has been filled in) above the door, continues to be owned by the family and now houses an antiques store. (HBS.)

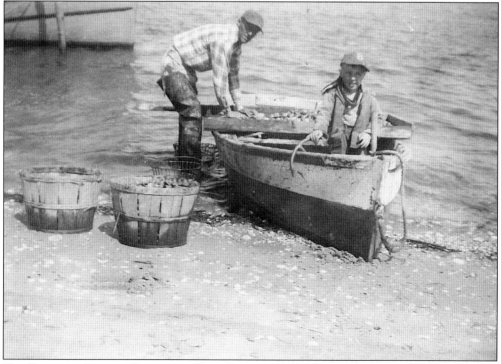

THE JACKSONS AFTER A SUCCESSFUL DAY CLAMMING, C. 1948. Walter H. Jackson and his son Walter are pulled up near Canoe Place, also known as Flat Fish Alley, on Shinnecock Bay. Like many residents of Hampton Bays, the Jacksons supplemented their income through clamming and shellfishing in the waters around Hampton Bays. (HBS.)

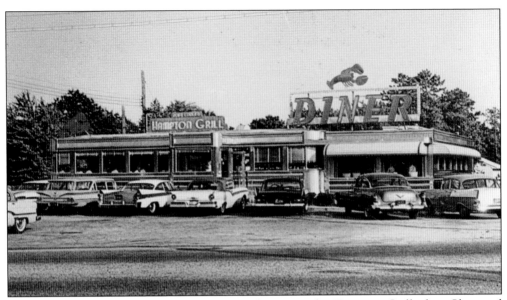

HAMPTON BAYS DINER, 1950s. The diner was known as the Hampton Grill when Chris and George Kamages, who also owned the Twin Diner located in Riverhead, opened it in 1947. The Hampton Bays diner originally was located in a smaller structure east of the building pictured, opposite the end of Route 24 and Montauk Highway. Frank Vlahadamis moved from Queens to Hampton Bays in 1982 and purchased the present diner from the Charos family, who had owned it since the early 1950s. The building—though much altered—remains in the same location today. (HBS.)

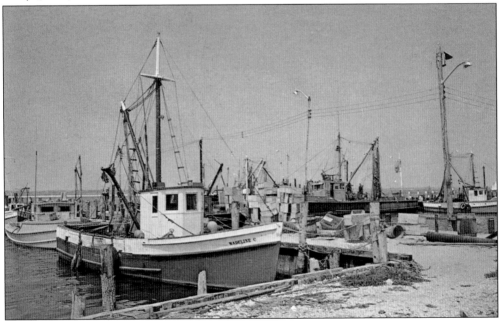

FISHING BOAT MADELINE C AND PIERS, 1970s. Fishing has always been an important part of life in Hampton Bays. Commercial vessels like these were often found docked on the north side of the barrier beach close to the inlet (after it was opened permanently), where they supply fresh seafood to a number of nearby restaurants to this day. (HBS.)

Ten

LIFE-SAVING AND COAST GUARD STATIONS

The United States Life-Saving Service (USLSS) began in 1848 out of the need to protect the lives of mariners and travelers who found themselves shipwrecked along the American coast. Originally, small stations were established and filled with supplies; however, they were unmanned. A terrible storm that took place in 1854 revealed the inadequacies of these poorly equipped stations and their equally poorly trained volunteers. Funds were then provided for stations to have at least a full-time keeper and two superintendents. By 1871, the structure of the service was taking shape as Sumner Increase Kimball was appointed chief of the Revenue Marine Division of the US Treasury, which oversaw Life-Saving stations and their crews. Kimball formally organized the service and secured funding from Congress to upgrade stations and equipment, as well as establishing standards for the men serving at the stations. In the Northeast, Life-Saving stations were established at regular intervals along the coast, and though initially manned only during the active season of April through November, by 1900, most were manned all year long. After many decades of successful rescues, in 1915, the USLSS merged with the Revenue Cutter Service to become the US Coast Guard.

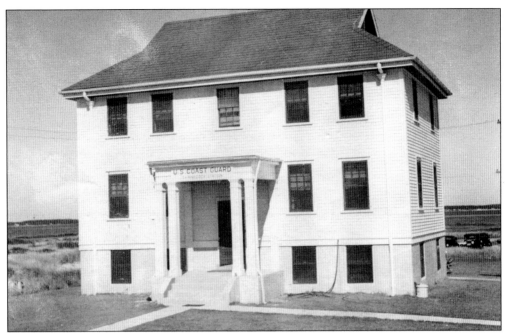

THE OLD COAST GUARD STATION, C. 1937. This predecessor to the new station disappeared completely during the hurricane of September 21, 1938. A witness to the destruction, George E. Burghard, reported the following: "It was a terrible sight, but more so because of the absence of noise. The main building, 60 x 50 and two stories high—hit the bay and smashed to pieces, throwing lifeboats in all directions. The effect was that of a silent movie—there wasn't any sound. Although only a few hundred feet to leeward we could hear none of the break up crash, the 110 mph wind took care of that." (HBS.)

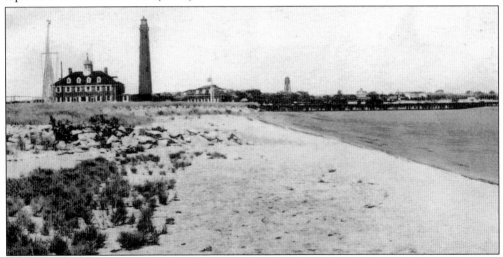

LIGHTHOUSE AND NEW COAST GUARD STATION, 1940s. Once the Hurricane of 1938 had removed the old station, a new one had to be planned. It was sited just south of the lighthouse, in a much safer position than the earlier station. Built of red brick, it was designed to withstand very strong storms and was completed in 1941; it still stands today, with some minor alterations, including its bright white paint. The present-day mission of the Shinnecock station is "Search and Rescue, Law Enforcement, and Homeland Security on the South Shore of Long Island." (HBS.)

SHINNECOCK LIFE-SAVING STATION, C. 1900.
Built in 1855, the original station was
first located "two miles east-southeast
of Shinnecock light" along the
barrier beach just to the east
of the present Shinnecock
Inlet. This building was
replaced during World War
I. (SHS.)

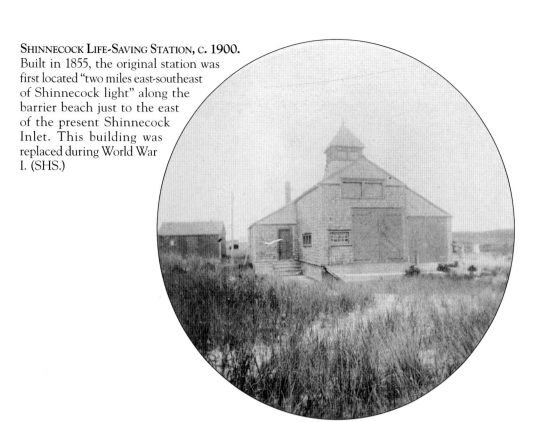

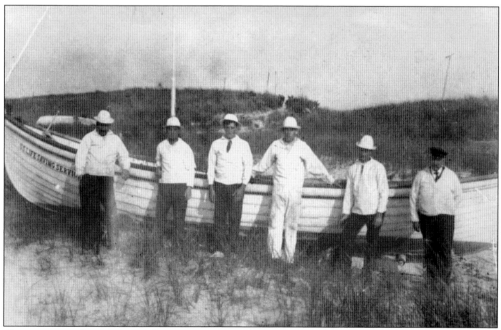

CREW OF THE SHINNECOCK STATION WITH THEIR RESCUE BOAT, 1900s. Among those in the
picture are John Edwards and Capt. Alanson C. Penny. Captain Penny (1854–1928) was the
longest-serving keeper of the Shinnecock station. He took over from William H. Carter in 1891
and served until 1915—a run of 24 years. (SHS.)

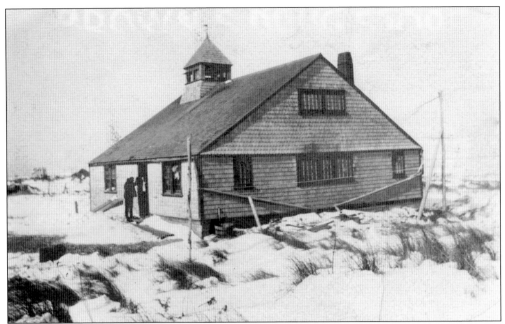

TIANA LIFE-SAVING STATION. 1900s. Completed in 1871, the Tiana station was located on "Tiana Beach, abreast of Shinnecock Bay, and 2 3/4 miles west southwest of Shinnecock Light" on land that somehow had never officially been acquired by the US government. This building was replaced with a new structure in 1912, but it was abandoned by the service in 1946. (SHS.)

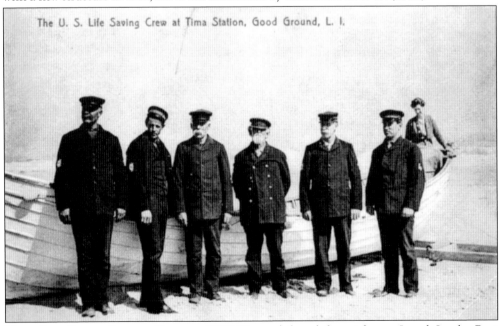

The U. S. Life Saving Crew at Tima Station, Good Ground, L. I.

TIANA LIFE-SAVING STATION CREW, C. 1899. Pictured, from left to right, are Joseph Jacobs, Burt Raynor, Ben Raynor, John E. Carter, Charles Lane, and Evert R. Weston. Posed on the boat in the background is Mable Squires Weston. Keeper Carter served even longer than his compatriot Alanson Penny at Shinnecock, taking over in Tiana from David A. Vail in 1886 and finally retiring in 1915, after 29 years as head of the Tiana station. (SHS.)

BIBLIOGRAPHY

Bellows, Emma L. *When Hampton Bays was Young*. New York: unknown printer, c. 1980.

Brooklyn Daily Eagle. Assorted articles, 1845–1940.

County Review. Assorted articles, 1904–1950.

Hampton Bays News. Assorted articles, 1930–1970.

Hunter, Lois Marie. *The Shinnecock Indians*. Westhampton Beach, NY: The Hampton Chronicle, 1960.

Long Island Traveler. Assorted articles, 1872–1898.

Moeller, Barbara M. *Historical Profile of Hampton Bays, Phase 1, Good Ground*. Southampton, NY: Southampton Town, 2005.

———. *Historical Profile of Hampton Bays, Phase II*. Southampton, NY: Southampton Town, 2007.

Newsday. Assorted articles, 1960–2010.

New York Evening Post. Assorted articles, 1890–1925.

New York Evening Telegram. Assorted articles, 1890–1925.

New York Herald. Assorted articles, 1890–1925.

New York Sun. Assorted articles, 1890–1925.

New York Times. Assorted articles, 1860–2010.

Port Jefferson Echo. Assorted articles, 1892–1931.

Suffolk County News. Assorted articles, 1900–1970.

Wettereau, Helen M. *Good Ground & Its Nautical History*. Yaphank, NY: Searles Graphics, 2000.

———. *Good Ground Remembered*. Southold, NY: Academy Printing Services, 1983.

———. *Shinnecock Hills Long Ago*. East Patchogue, NY: Searles Graphics, 1991.

DISCOVER THOUSANDS OF LOCAL HISTORY BOOKS
FEATURING MILLIONS OF VINTAGE IMAGES

Arcadia Publishing, the leading local history publisher in the United States, is committed to making history accessible and meaningful through publishing books that celebrate and preserve the heritage of America's people and places.

Find more books like this at
www.arcadiapublishing.com

Search for your hometown history, your old stomping grounds, and even your favorite sports team.

Consistent with our mission to preserve history on a local level, this book was printed in South Carolina on American-made paper and manufactured entirely in the United States. Products carrying the accredited Forest Stewardship Council (FSC) label are printed on 100 percent FSC-certified paper.

MADE IN THE